STEPHEN
DE STAEBLER

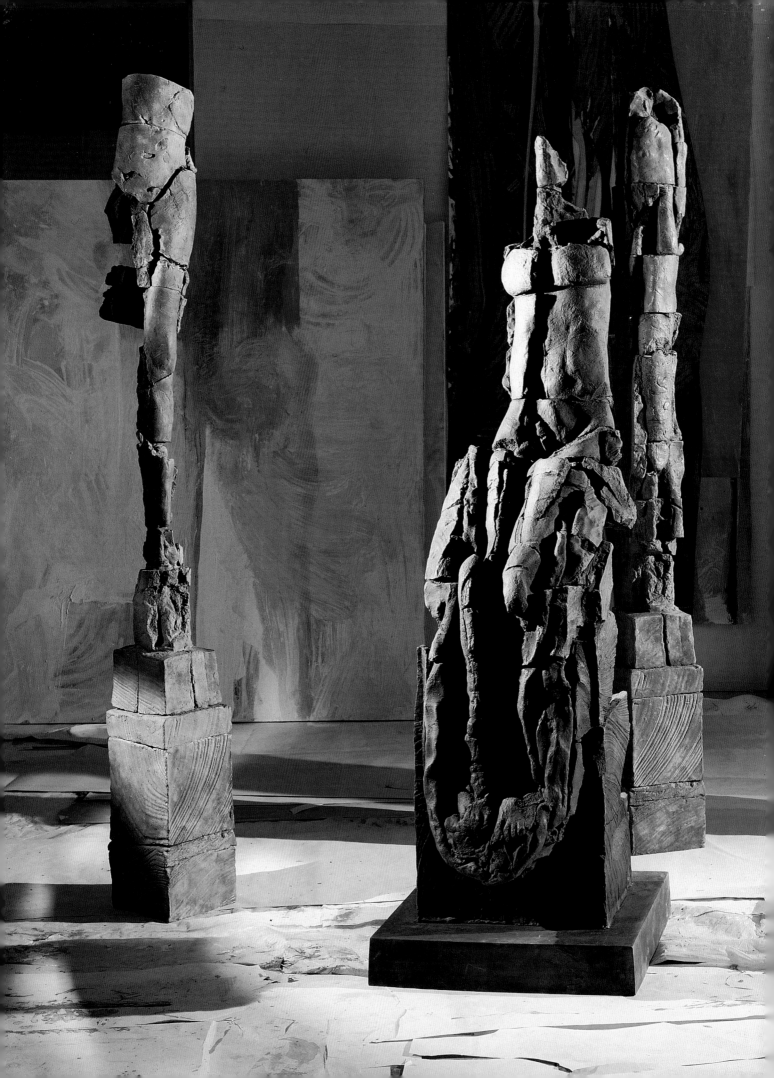

STEPHEN DE STAEBLER

THE FIGURE

Essay by Donald Kuspit

Exhibition organized by Lynn Gamwell

Chronicle Books, San Francisco

Laguna Art Museum and Saddleback College

This book was published on the occasion of the exhibition
Stephen De Staebler: The Figure.

Exhibition Tour

San Francisco Museum of Modern Art
San Francisco, California
February 25–April 17, 1988

Neuberger Museum
State University of New York at Purchase
Purchase, New York
June 23–September 11, 1988

Renwick Gallery of the National Museum of American Art
Smithsonian Institution
Washington, D.C.
October 21, 1988–February 12, 1989

Krannert Art Museum
University of Illinois
Champaign, Illinois
March 3–April 23, 1989

Laguna Art Museum
Laguna Beach, California
Saddleback College
Mission Viejo, California
June 2–September 10, 1989

The exhibition *Stephen De Staebler: The Figure* was funded
in part by a grant from Philip Morris Companies Inc.

Design and production: Ed Marquand Book Design
Printed in Hong Kong

Library of Congress Cataloging-in-Publication Data
Kuspit, Donald B. (Donald Burton), 1935–
 Stephen De Staebler, the figure.

 Bibliography: p.
 1. De Staebler, Stephen, 1933– —Exhibitions.
2. Human figure in art—Exhibitions. 3. Sculpture,
American—Exhibitions. 4. Sculpture, Modern—20th
century—United States—Exhibitions. I. Title.
NB237.D49A4 1988 730'.92'4 87-27659
ISBN 0-87701-508-2
ISBN 0-87701-496-5 (pbk.)

Frontispiece: Stephen De Staebler's Berkeley Studio, 1981
Page 6: Stephen De Staebler in his studio, 1986.

Chronicle Books
San Francisco, California

CONTENTS

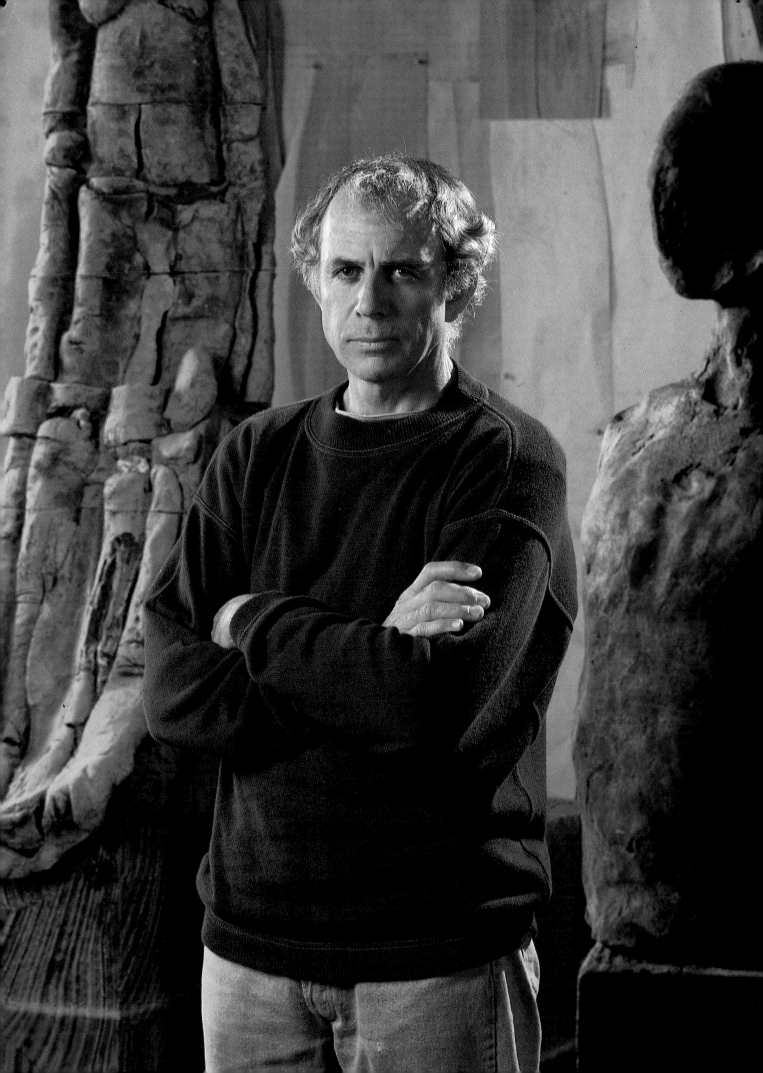

FOREWORD

Stephen De Staebler creates some of the most powerful images of mankind in American sculpture today. His timeless figures both echo the past and express the human condition in the late twentieth century. This presentation of the art of Stephen De Staebler is an occasion to reflect on the essence of the human experience.

The exhibition represents the Laguna Art Museum's ongoing commitment to significant American artists residing in California. It has been the museum's privilege to be a cosponsor and to work with the Saddleback College staff in the development of this important exhibition and publication.

William G. Otton, *Director*
Laguna Art Museum

7

Saddleback College is proud to have organized the Stephen De Staebler exhibition and publication, and is most grateful for the cosponsorship and support of the Laguna Art Museum. This project is a significant step in the expansion of Saddleback College Art Gallery programs benefiting our students, staff, local community, and the larger art world.

Stephen De Staebler is one of the finest American sculptors working today, and it is a special privilege to bring his art to southern California and the nation. He is an artist deeply concerned with environmental issues and with problems of the nuclear age. It has been an honor to come to know, as an artist and a friend, such a morally committed man.

Saddleback College enjoys the continuing support of Philip Morris Companies Inc. and Mission Viejo Realty Group and its operating companies, Mission Viejo Company and Mission Viejo Business Properties. They have aided the development of fine arts programming in southern Orange County. I am especially grateful for their generous grants in support of the Stephen De Staebler exhibition.

This exhibition and publication would not have been possible without Lynn Gamwell, who initiated the project in 1985, when she was director of the Saddleback College Art Gallery and a curator at the Laguna Art Museum. She has curated the exhibition with sensitivity and energy, bringing the project to a stunning realization.

Gregory J. Bishopp, *Dean of Fine Arts and Communications*
Saddleback College

ACKNOWLEDGMENTS

Stephen De Staebler: The Figure was made possible by the combined efforts of many people. The starting point was the art of Stephen De Staebler and the profound outlook on humanity it so beautifully expresses. Everyone associated with this project has been touched by that viewpoint and has worked together to make the strongest possible presentation. Special thanks go to Betty Turnbull, Exhibition Advisor, whose wisdom guided the project throughout its development.

Donald Kuspit's essay provides an insightful and articulate critical response to De Staebler's sculpture. I respectfully acknowledge his understanding of contemporary art and his contribution to this project.

The Laguna Art Museum cosponsored the exhibition and generously supported the catalogue. I am especially thankful to Director William G. Otton for his help in the organization of the tour. Pamela Alison advised on matters of registration, and Anne Naleid assisted with publicity.

Saddleback College Art Gallery assumed the weighty task of initiating a national exhibition. President Constance M. Carroll gave unwavering institutional support to this ambitious project from its inception. Dean Gregory J. Bishopp displayed the administrative skill that keeps him so dear to the hearts of his staff by meeting the needs of a fine arts project within the college's complex structure. I cherish Greg's guidance as "boss" and as a friend. Patricia Boutelle graciously assumed the supervision of the project at the college when she succeeded me in 1987 as director of the gallery. The catalogue was given an added scholarly dimension by the thorough exhibition history and bibliography, which were meticulously compiled by Karene Gould, assisted by Michelle Greene. Installation models of the tour sites were prepared by the Gallery Display classes of 1987, who followed plans drawn by Larry Barber. Kathleen Brennan's tidy mind kept the books straight, and Susan Lemkin expertly assisted with publicity. Throughout the project, hundreds of details were handled and problems nipped in the bud by office manager and beloved friend Helen Brinkmann.

Clara Diament Sujo, director of CDS Gallery in New York, gave generous support and valuable advice on many aspects of the project. Her staff was very helpful in obtaining the complex bibliographical and exhibition information needed.

John Berggruen, owner of John Berggruen Gallery in San Francisco, showed very strong interest in the project and generously provided support for the exhibition catalogue.

Much of the work in this exhibition is on loan from private and public collections. The exhibition's national tour is quite lengthy, and I wish to commend the lenders for their consideration of the artist's career and their concern for the public's access to fine contemporary art.

The exhibition benefited from the generosity of private and corporate donors. Martin Z. Margulies and William Matson Roth, both collectors of De Staebler's work, showed their support for documenting the artist's work through their contributions. Constance M. Carroll, President of Saddleback College, demonstrated her personal support of this project by contributing a generous private donation to support this scholarly publication.

I am especially grateful to Stephanie French, Cultural Affairs Director of Philip Morris Companies Inc., and Wendy Wetzel, Director of Corporate Affairs of Mission Viejo Realty Group, for their help in negotiating the corporate grants from their companies, which provided substantial funding for this project.

Ed Marquand Book Design expertly handled all the complex aspects of the production, printing, and copublishing of this book. Ed Marquand's fine aesthetic sense as a designer can best be summed up by simply taking a moment to look at the book's cover. It speaks for itself. Suzanne Kotz's thorough and patient editing gave the manuscript its finishing touch.

Lastly, I would like to acknowledge the strong support I received from Stephen De Staebler as we worked together during the last several years. He showed consistent concern for the highest quality in both the exhibition and the publication, and he was always considerate of the efforts and needs of the people involved in the project. In the end, I value most the tremendous amount I have learned from Stephen about art. That is what it was all about.

Lynn Gamwell
Curator of the Exhibition

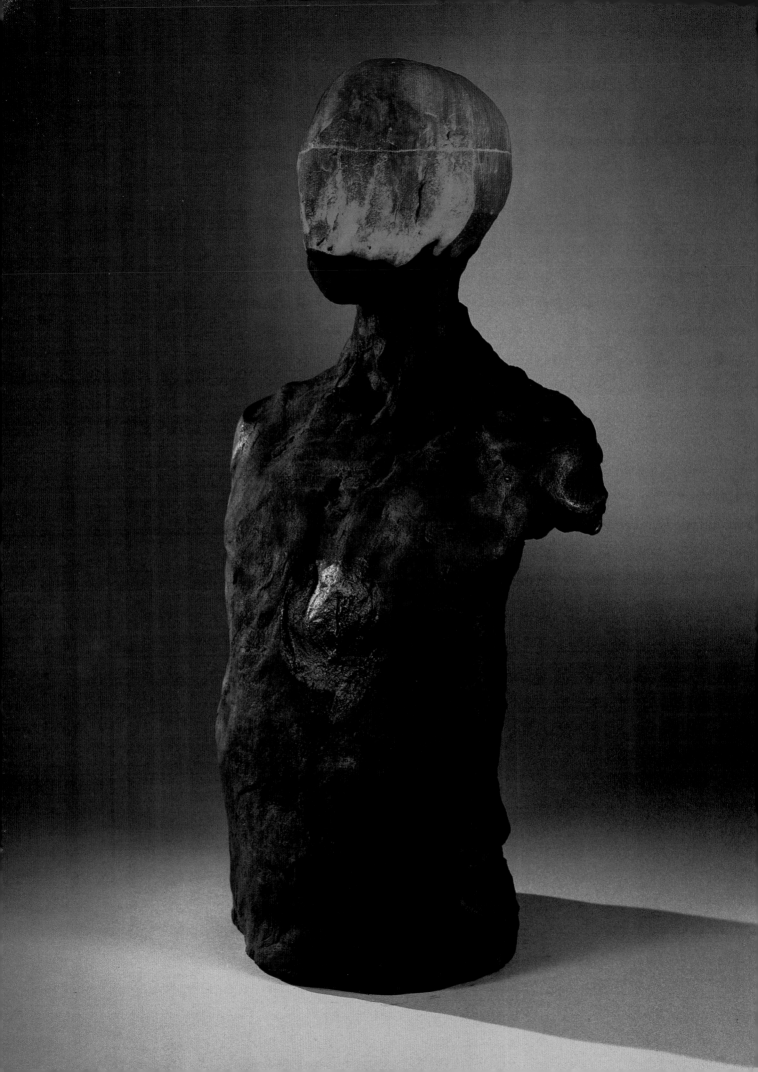

STEPHEN DE STAEBLER'S ARCHAIC FIGURES

. . . that wholly peculiar feeling which arises in us if, for example,
in the noise and tumult of a modern street we should come across
an ancient relic — the Corinthian capital of a walled-in column,
or a fragment of inscription.

 C. G. Jung, *Psychology of the Unconscious*

Art of the highest calibre pushes beyond totality towards a state
of fragmentation.

 T. W. Adorno, *Aesthetic Theory*

Stephen De Staebler once described a Spanish colonial church in
Mexico as "a straightforward abstraction of the female figure with
knees up, the pubic hair articulated by the statuary over the entrance,
and the dome the breast" — an almost straightforward translation of
"mother church." Such "almost simplistic imagery," De Staebler said,
commenting on his own visionary description, on the peculiar feeling the
church gave him, "is at the heart of art."[1] De Staebler's own art, it seems
to me, is an attempt to strip the human figure down to its most elemental,
"almost simplistic," terms, revealing it in all its archaic bodiliness. He
wants to disinter it from its modernity — the sense of its purely functional
significance, of its ideal existence as that of a happy machine — and recover
a sense of its flesh as morbidly immediate if also cosmic in import, linked
to the strange tumult of raw matter in formation. All this is conveyed by
the archaism of De Staebler's figures — their regressive character, all the
more peculiar in that his figures retain a certain ironic individuality. They
do not slip totally into the fetal material from which they emerge, for, even
when they are pointedly elemental, they remain personages. De Staebler's
Pregnant Woman (1982) is dumbly weighted with her outsized belly, next

Man with Tar Heart, 1981, bronze and tar, 26½" h.

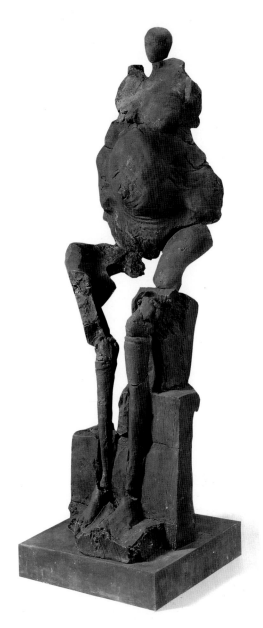

Pregnant Woman, 1982, bronze, 78" h.

to which her head is a diminished non sequitur, but that petty head still has personality, a certain unspeakable, wispy sense of self finally more mysterious than the mysterious life forming in her. There is a strong, if residual, trace of self in the attenuated, abstracted features of her face. She may be archaic mother, dominated physically by her motherhood, but she remains spiritually independent of her burden, her head — symbol of the self — at once ecstatically etherialized yet assertively alert, autonomous despite being part of the body. The head may have become small because the belly became big, became the effective whole of the body, but the head has the grand integrity of its own consciousness, whatever its physical size.

Art historically, De Staebler's figures are archaic because they are full of recollections, almost saturated with them. His numerous embedded figures recall the giant figures carved in the living rock of the temple of Rameses II at Abu Simbel (ca. 1257 B.C.). Like these figures, De Staebler's

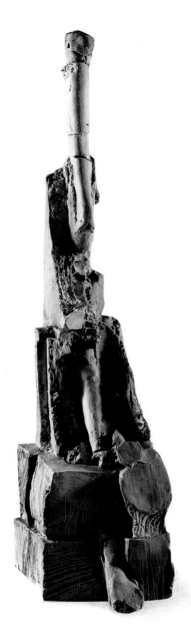

Altar to a Leg, 1981, bronze, 55½" h.

seem to be in a niche of their own making. They are buried in earth but stand in transcendent outline against its mass, imbued with, but peculiarly distinct from, its gravity. There's antiquity for you, an Egyptian antiquity that was already old when the Greeks conceived their archaic statuary. The static sublimity of the Egyptian figures — and those attached to the walls of Christian cathedrals in another kind of religious sculpture — reappears in De Staebler's figures, with the same religious import.

The elongated character of many of De Staebler's statues, almost to the point of attenuation in such works as *Altar To A Leg* (1981) and other celebrations of the part of the body closest to the earth — mediating between the rest of the body and earth — as well as in various overt stele pieces, such as *Phoenix Stele* (1979), or covert ones, such as *Standing Woman With Twisting Torso* (1979), innovatively extend the tradition of modern figural archaism evident in the sculpture of Wilhelm Lehmbruck

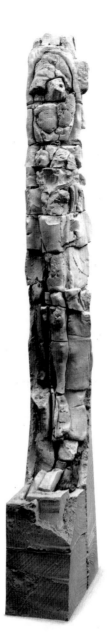
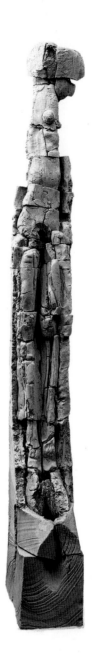

Phoenix Stele (left), 1979, clay, 106" h.
Standing Woman with Twisting Torso (right),
1979, clay, 107" h.

and Alberto Giacometti, not to speak of their relationship to the archaic, "broken" figures in such paintings as Pablo Picasso's *Demoiselles d'Avignon* (1907), equally sacred. There is a commemorative, religious dimension to the figures of Lehmbruck and Giacometti, and, I would venture to say, to Picasso's confrontational female figures, who block our path like the "bewitching" Mothers Goethe alludes to in the second part of *Faust*. De Staebler's figures are also found in the bowels of the underworld, guarding the path to its deepest secret.

And of course the commemorative stele — virtually all of De Staebler's figures are stele-like in function if not in form — is an ancient form, boldly asserting the presence of the dead, usually presented in generalized form (as in De Staebler's stelae), in collective memory. The stele is a memorable form — a form that can easily be fixed in memory — articulating a memorable experience, which one hopes would endure and be

repeated. (The human figure is already fixed in memory, being ourselves, so that to make it stele-like is to make its primitive memorableness emphatic.) The stele addresses the suffering of loss of the beloved, who is resurrected in primitive form. (De Staebler, I am going to argue, addresses the loss of our primitive sense of being human, in effect our primitive sense of ourselves.) It is a religious art form. De Staebler has said that "religion ... addresses suffering,"[2] and that art tries "to restructure reality so that we can live with the suffering."[3] He wants to create a modern religious art, utilizing archaic forms for an "archaic" purpose: the articulation and remediation of suffering. This generates the illusion of release from time and space we call "eternity." De Staebler's archaic figure symbolizes the process that leads to the eternal effect — that uncovers the eternal presentness of the primitively memorable — and the effect itself. It is about the impacted sublimity of our feelings for those we cherish, most of all, for ourselves. It is an at once sublimely and primitively reparative narcissistic art of memory.

Rodin, of course, is not forgotten in De Staebler's sculpture, with his sense of the infinite malleability and expressivity of clay, and his ability to generate a sense of the figure as simultaneously molded and carved, fusing what the critic-philosopher Adrian Stokes regards as the traditional opposites of sculpture making. Inseparable from this Rodinesque aspect, there is a baroque complexity to De Staebler's statues, a sense of visionary elaboration of an intuition of mysterious being in order to keep it steadily in focus. The human figure is the most immediate vehicle of this intuition, and it is worked and reworked by De Staebler until it becomes emblematically vibrant with mysterious being, greater than itself yet unexpectedly inseparable from it. What began as a schematically fetishized figure ends as a transcendentalized physical plenitude, conveying a sense of being bursting the order of the body, but needing the body as its flexible expression, as the ironical access to it. Even the fetishized figural part, which De Staebler is so expert in articulating as a whole in itself, can suggest mysterious ultimacy and limitlessness of being, which no form is adequate to — which insatiably consumes all forms, leaving them in fragments, masterpieces of inadequacy. It is enough to intuit the uncontrollable mystery of

primitive being — the most primitive of mysteries — through the sculptural/ bodily fragment, for it finally belongs neither to the order of the body from which it came nor to any order of art, but to the mystery of being itself. The fragment is the form in which primitive being makes itself most manifest.

De Staebler has expressed admiration of baroque "daring" for playing so "tenaciously with the idea of underlying order overpowered by a kind of multiplicity of form that camouflages that order." One intuits the latent order through the manifest play of forms within the figural context, as though the sculptural figure is a dream to be interpreted. De Staebler wants this same "theatrical" effect: "It's that quality of having an order which is very unapparent — which is submerged in the form — that really satisfies me. And that's what the experience of nature is."[4] (I think De Staebler's often disconcertingly bright paint serves his baroque purpose particularly well. Its free play on the body suggests the "alternate" primitive order the body has.) De Staebler transposes that quality to his art: a secret sense of permanent primitive order in a sophisticated cocoon of formal manipulations, a mysterious deep order under a hyperactive surface tending towards revelatory formlessness, that is, towards the condition of unmediated materiality that implies the rootedness of the primitive bodily order in primitive being. The effect of being unformed — chaotic, the ultimate primitiveness — is all the more vivid for having been achieved by harrowing passage through a multitude of forms.

In general, from the matrix of "suffering" material, a sense of memorable, if not immediately specifiable, figural order emerges, fraught with mysterious consequence. De Staebler's figural sculpture wants to initiate us into this archaic, irreducible, elementary order — the secret order of the figure — which is so hard to experience, and seems "almost simplistic" when it is finally formally realized, or rather, signaled and symbolized. De Staebler's figures verge on the inarticulate and inchoate — seem full of nonhuman natural forms — in order to express the rootedness of being human in nature's apparent randomness. For De Staebler this randomness is occult in import, for, like the fragment, it is a point of access to primitive being, a kind of spontaneously given source through which it seeps up.

Here we come, inescapably, to De Staebler's sense of clay, the clay out of which his figures are made. Clay for him is the immediate form of nature. Clay is prehistoric, prehuman. The human is one more "landscape" that has emerged from clay, a landscape that seems as random in character as any other. The human is random in appearance — for all its definiteness, De Staebler's figure still conveys the indefiniteness of the clay out of which it is made — and it is, as De Staebler wants to suggest, randomly put together, not as fixed an order as it seems. Thus he "randomly" alters its proportions and emphasizes certain parts at the expense of others. De Staebler's figures are randomly metamorphic, as randomly metamorphic as clay. It is hard to determine whether his figures are still in the process of being formed, or malformed, or formed piecemeal — different parts at different rates — or in the process of disintegrating into formless fragments. They are absolutely ambiguous in character, inhabiting no one condition stably. For all the residual heroic aura they muster, his figural bodies are incoherent, almost to the point of monstrousness. This is true even for such torsos as *Man with Tar Heart* and *Man with Lip-Eye* (both 1981). They seem to symbolize the "abnormality" of the human figure, that is, the lack of any norm of the proper human body. Certainly compared to the wholeness and nobility of classical ancient figures De Staebler's archaic figures seem not only far from ideal but outright pathological, dysfunctional — anti-functional. De Staebler's "ill-formed" archaic figures pose a threat to the mature figures of antiquity, which have become a symbol of authentic, model humanity — indeed, De Staebler's seem to dismiss them as a big lie.

The root of De Staebler's peculiarly abortive figures — randomized (almost to the point of being impulsive) and fragmented (in part a strategy of randomization) — is in clay. "The thing that I responded to mostly in clay," De Staebler has said, "was its power to perform randomly. You could let it do what it wanted to do. It had this great power to receive order, but also to persist in its randomness. In that sense, it's landscape, because landscape itself is randomness being acted upon by overwhelming forces, which have only recently been discovered or understood. You think of earth crust movement, plate tectonics and so forth. This is very much like

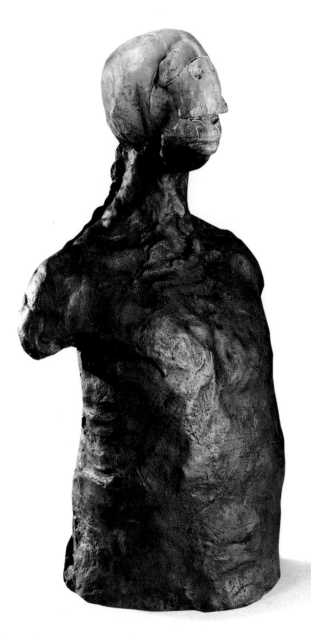

Man with Lip-Eye, 1981, bronze, 26½″ h.

the experience you have when you work with clay but let the clay have its head, to do what it wants to do."⁵ One feels this randomness coming through in De Staebler's figures, both generating and degenerating them, that is, shaping yet regressing them to shapelessness. This is exactly why De Staebler's archaic figures are archaic — because clay is the ultimate "archaic" material. De Staebler's archaic figure can never be fixed in form, however familiar its form is — but never so familiar as to seem everyday — for it seems always to be breaking the boundaries of form in the very act of articulating them. In a sense, this is why De Staebler must wedge the figure in: to get a hold on it. His figure always seems forced into shape, and to spill out of it spontaneously. Its clay substance naturally merges, as it were, with the comparatively formless primitive nature that encompasses it, that gives it "body." This primitive merger effect is obvious even in the very sophisticated, mythologically powerful *Seated Man with*

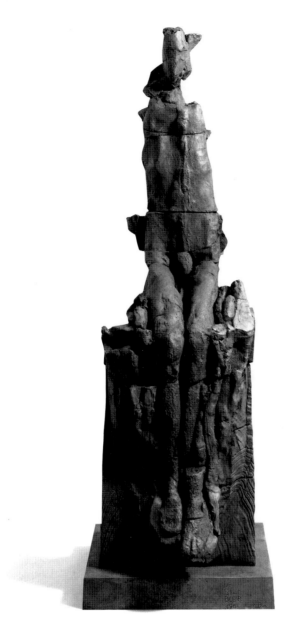

Seated Man with Winged Head, 1981, bronze, 67½" h.

Winged Head and *Seated Woman with Oval Head* (both 1981). The figures seem to grow out of thrones of earth or stumps of trees — out of a fragment of landscape. They may be differentiated from their organic pedestals, but they are inseparable from them. Moreover, for all the refinement and polish of their limbs and heads, they remain insistently primitive. It is almost as though the figures, in "randomly" emerging from the matrix of raw material, were reluctant to give it up, however resistant to it they are.

The tendency to formlessness associated with the organically raw in general and romantic landscape in particular is evident in the sense of generic force De Staebler is eager to articulate — the force in earth crust movement, in plate tectonics. (It is a tendency perhaps most straightforward in the *Farnsworth Memorial Sculpture* (1969), which, looked at from the perspective of De Staebler's later development, can be conceived as a rudimentary pedestal or throne of earth awaiting the archaic

Farnsworth Memorial Sculpture, 1969, clay and bronze, 44½″ h. and 17″ h. Permanent installation at the Oakland Museum.

figure that will grow from it.) The figure at times seems like an arbitrary vehicle for articulating this force, with its variety of rhythms, which affect the structure of the figure as though its parts were so many plates in clashing movement, or as though it was merely a hardened crust of clay of geologic value for plotting the earth's changes with time. There is indeed a strong archaeological aesthetic to De Staebler's figures, as though they were samples from some tomb of cosmic time. The figure seems imposed on the rhythm of energy in the formless material. At the same time, it suggests the human capacity to tap into and channel this primordial energy. Nonetheless, De Staebler's figures seem peculiarly tentative, which is part of their archaism. De Staebler may breath life into and give shape to his clay, but it has a shapeless life of its own — a primitive formlessness at whose mercy the figure precariously exists.

What are we to make of De Staebler's use of bronze? I think it represents a residue of the perfectionism De Staebler once felt himself to be tyrannized by — a new way of handling, of making peace with, that still-operational perfectionism. De Staebler turned to clay because of his great sensitivity to the "secret processes" that he feels are at work in it. He is fascinated with the fact that there is no other medium "that has so many individual states," beginning "with slip, then slop, then sludge, and very gradually ranges into whatever you want to call it."[6] All the "s's" convey

the inherent sensuality of the process of change from state to state — the directly libidinous quality of clay that makes it so ultimately interesting for De Staebler. Working in clay is a sensual liberation from his perfectionism, as well as sensually enjoyable in itself. Clay represents pure impulse for De Staebler. But the repressive, egoistic perfectionism would not go away, and is indeed evident in De Staebler's meticulous control of detail. De Staebler says that we ought to have at least as many words for clay as the Eskimos have for snow — about twenty. He is fascinated with the change that occurs in clay as it is shaped, when, becoming less "soft, plastic" and a "little stiffer and leather hard," it "starts to resist shaping, and … begins to gain structure."[7] Even waiting on the clay — as it dries, as it is fired — is part of the unique process of the medium. The unpredictable, seemingly miraculous result of firing — De Staebler speaks of it with awe — is the antithesis of the control that De Staebler wanted with his perfectionism. So why should he return to the obvious perfectionism of bronze — a seemingly changeless, and so implicitly perfect, material, fixing eternally whatever form it embodies? I think it is because De Staebler is now mature enough to acknowledge the role of his perfectionist tendency in his sculpture making, to the extent of hypostatizing it. It is also a baroque necessity, for his perfectionism is responsible for the sense of order underlying the impulsive play with the clay, and must be given its independent due.

De Staebler's use of bronze suggests that he is ready to acknowledge that there is no complete liberation of impulse — randomness is itself an incomplete liberation of impulse — and that the desire for and regressive ideal of such liberation is false to the complete truth of being human, which also involves being civilized, that is, controlled, or channeling — censoring and "criticizing" — impulse. Regression to impulse may be necessary at a certain youthful moment in development — De Staebler has spoken of the need of young artists to free themselves from the tyranny of the apparent perfectionism of old masterpieces, even to deliberately seek out their impulsive root, their "imperfection" — but it cannot carry development forward, however much it may initially liberate it. Bronze is a civilized material, and to hypostatize bronze, and use it to hypostatize clay,

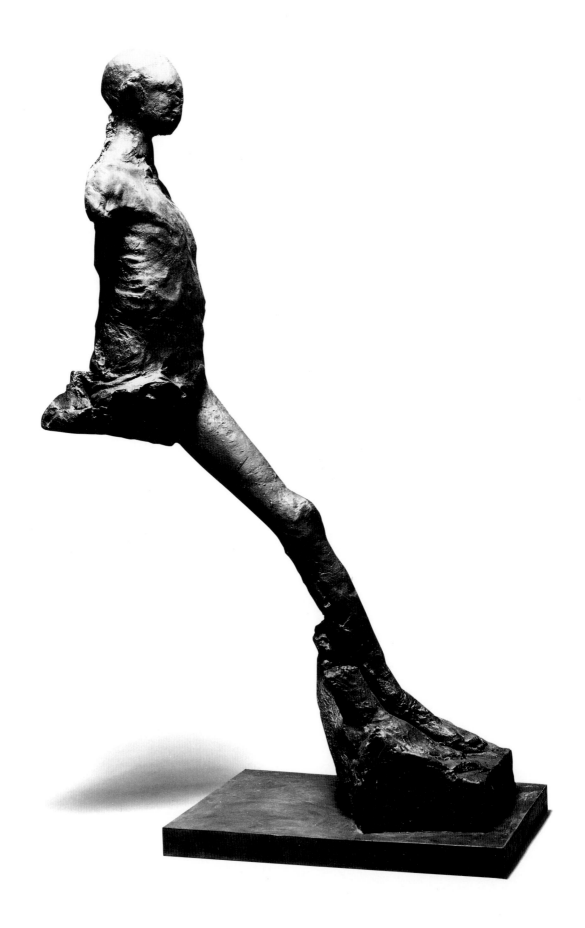

is to accept the idea of a necessarily civilized development of art — rather than simply self-indulgently primitive, infantile art — and of clay. Indeed, giving form to clay was one of the first signs of being civilized, and is already a criticism and censorship of the raw state of nature. Where working with clay was once liberation from the repression represented by perfectionism for De Staebler, casting in bronze involves the recognition of the necessity of what has been called the repression barrier for civilization. Bronze monumentalizes that barrier as a virtue, and in doing so confirms clay's meaningfulness beyond its randomness. De Staebler has not given up the impulsiveness that clay is so conducive to. Rather, he has realized that it is only half its story. By bronzing, he acknowledges his total mastery of the states of clay. And he reconciles the opposites in himself, that is, the criticality represented by perfectionism and the impulsiveness represented by clay. He has achieved autonomy.

De Staebler, as might be guessed from what has been said before, is interested not only in creating an archaic figure but an archaic surface, what he calls "a surface of landscape."[8] Landscape has as complex a meaning as life. The key point in De Staebler's understanding of landscape is that it is not something distant, out there, which he passively contemplates, but something close up, in which he can immerse himself. It represents intimacy with elemental substance and the sense of discovery of fundamental reality through that intimacy, as his reference to a famous passage in Thoreau's *Walden* suggests. Thoreau, writes De Staebler, "wanted to burrow like a mole, to mine with his forepaws and brain, and cut to the truth."[9] De Staebler wants to burrow into clay, trace and symbol of earth, mine it for the truth of being with his hands and brain. The animality of the relationship to the clay is crucial, for only through the passionateness it represents can the "truth" — the "hard bottom," as Thoreau called it, that we come to after we "work and wedge our feet downward through the mud and slush of opinion, and prejudice, and tradition, and delusion, and appearance" — be reached. Thoreau names this hard bottom, all of whose rocks are in place, "reality" — what unmistakably is. Clay here does double duty, as a symbol of the delusion that is the obstacle to recognition of reality, and of bedrock reality — so flexible is

Seated Man with One Leg, 1983, bronze, 63″ h.

it, so symbolically useful its various forms. It is this same sense of basic contact with bedrock reality after working through clay that De Staebler wants in his final sculptural product.

There is a paradox here: soft clay hardened into ceramic art becomes emblematic of bedrock reality. There is a further paradox in the fact that bedrock reality takes the form of the archaic figure. Why is the archaic figure particularly relevant now, in our modern society of instrumental reason? It is a question of postmodern expressionism, which De Staebler's art can be said to be a branch of. The usual answer — that the irrational figure is a reminder of our buried roots and a response to a false rationality — is only partially true. The truth of De Staebler's figure is deeper. It articulates not simply human irrationality — a defiant primitivism — but engages the necrophilia of the age. If, in the nineteenth century, the death of God was at stake, in the twentieth century the death of humanity is. De Staebler's figures and fragments of figures deliberately refuse, as it were, the streamlining or efficiency demanded of human beings in today's administered world, which is as unbiophiliac as more overt forms of social necrophilia, the catastrophes that constitute much of the history of this century.[10] De Staebler's figures are a critique of the false ideality of efficient functionality which plays into the hands of the collective death instinct. In their return to nature, they forfeit all modernistic streamlining, and as such are not only implicitly "skeptical of progress and technology," like De Staebler's hero Thoreau,[11] but a reminder that technologically inspired efficiency does not guarantee humanity's survival. One might even say that De Staebler works in clay because it is not a technologically advanced or new material, as it were, although ceramic material has recently played a major role in the development of superconductivity — which suggests how much life and use there still is in the old earth.

De Staebler articulates the secretly surviving rawly human being within the streamlined, efficient functionary demanded by society in its pursuit of progress and technology. His archaic figure represents the alive but devastated self within the efficient technocrat that is the ideal modern person. De Staebler's archaic figures are wounded survivors of the streamlining process that robotizes human beings into efficient operators.[12]

Their archaicism conveys their woundedness — their eroded, fragmented character. Monumentally isolated — grandly antisocial — as they are, and partially confined, as many of them are, in the earth, they reveal their social misfitness all the more. The pathological, inefficient state of their bodies suggests that they symbolize the alter ego or shadow side of modern technocratic man. Jung — De Staebler said that he liked Jung's theory of the psyche[13] — described the shadow as "the 'negative' side of the personality, the sum of all those unpleasant qualities we like to hide, together with the insufficiently developed functions and the contents of the personal unconscious."[14] De Staebler's figures symbolize the unconscious, decadent, injured condition of modern man. All the hopeful becoming in clay is used to negative purpose in De Staebler's archaic figures. Their primitiveness is an end, not a beginning. They are regressive ruins, yet they articulate the subjective complexity of being human. They show the human at its wit's end. But the shadow, as Jung said, contains the germ of "good qualities." They exist in the figure: they are the impulsive rather than eroded part of its primitiveness. They are, as it were, part of its unconscious — its character as clay. The unconscious is clearly claylike, so that as long as De Staebler's figures retain an obvious claylike malleability there is hope for and in them.

Jung's theory of archetypes is also relevant for an understanding of De Staebler's figures, which are quintessentially archetypal. Jung described archetypes as "*a priori* categories of possible functioning,"[15] and once used the metaphor of a deeply cut riverbed to describe the archetype. Such channels, shaping and containing the flow of our mental activity, exist in every psyche.[16] They are bedrock inner reality, not unrelated to Thoreau's sense of bedrock reality underlying the river of false opinion. De Staebler's figures are personifying rather than transforming archetypes. Where the latter symbolize — often through abstract means — changes underway in the psyche, particularly changes to bring it into balance, the former are projections of unconscious collective experience. They naturally take on a human-looking appearance, the act of personification being the most direct expression of the unconscious's influence on us. The most prominent personifying archetypes are the *anima* in man, representing his collective

experiences with woman, and the *animus* in woman, representing her collective experiences with man. De Staebler's archaic figures — this is another reason they are necessarily archaic — are representations of the *anima* and *animus* in the narcissistically injured condition in which they exist in the efficient modern world. At their most socially consequential — which may seem a strange way to speak of such symbols of interiority — De Staebler's figures articulate the wreck woman is to man and man is to woman, psychically speaking. That is, each is a wreck to the other, implying that neither can save the other from the efficient world. At the same time, each is potentially full of integrity, as its majestic appearance suggests. But it must realize this integrity by itself. This is not to reduce De Staebler's fragmentary figures and fragments of figures to a message but to comprehend them as outcries, stylistically holding their own in the great expressionistic tradition of the suffering figure.[17] If one compares De Staebler's couples to such Egyptian figures as Rahotep and Nofret from Medum (ca. 2580 B.C.) and the brother of Ramose and his wife at Thebes (ca. 1370 B.C.), or the couples on Etruscan sarcophagi (ca. 520 B.C.), one realizes how De Staebler's man and woman have abandoned each other — how separate from each other they are in comparison to the ancient loving couples — how the primitive, ageless intimacy of these archaic couples has degenerated in the modern world. De Staebler can make the archaic look freshly fascinating and sophisticated, but there is no way he can appropriate the tender spirit between these couples. De Staebler's figures are too panicked structurally to be intimate.

De Staebler has said that "for years" he has been involved "with the male-female polarity and [its influence on] the form of the body. All of my figures are either androgynous or nonsexual. Often, you do not know whether it is a male or a female figure. Or, if you see that it is a male figure, you see that it is also female." He is aware that "people who are insecure about their own sexual orientation, or who like things clear-cut, do not like this kind of ambiguity."[18] De Staebler's attempt to integrate these fundamental human opposites is also Jungian, for Jung held that the psyche is predicated on a "principle of opposites."[19] It is inherently ambivalent or contrapuntal, and it is to De Staebler's credit that he can

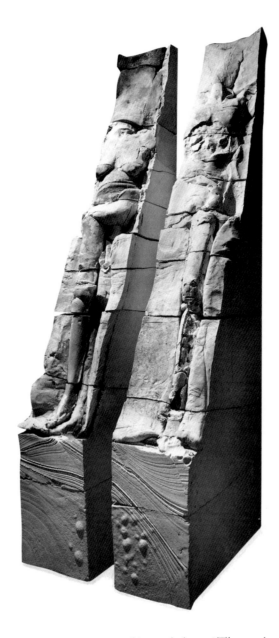

Standing Woman (left) and *Standing Man* (right), 1975, clay, 96″ h.

articulate this fact without losing the sense of its subtlety. (The articulation of ambivalence, as an end in itself, is one of the most important and difficult achievements of modernity. It must always be renewed — a renewal threatened by the postmodernist tendency to stereotype it into a simplistic matter of formal contrast. De Staebler is artistically modernist, but engaged with postmodernist ideological issues, adding to the ambivalence of his position.)

The male-female polarity is not just an issue of the articulation of body for De Staebler. He studied religion in college — his sense of "organized religion" as a "straightjacket" rather than a "creative vehicle"[20] is reflected in his artistic rebellion against perfectionism (ceramics became a kind of "disorganized" or "creative" religion for him) — where he "became aware of the two distinctive paths that religion has followed. One is a very male-oriented quest and the other is a very female-oriented quest.... The

male approach is to see God, and the female approach is to be absorbed in God. And this has everything to do with the question of individuation [another Jungian concept] of each human being who comes from a mother and a father. I had a teacher who referred to the quest of seeing the face of God as positive mysticism, and the quest of being absorbed in God as negative mysticism. The Eastern orientation is essentially female: Hinduism and Buddhism are involved with the nothingness of absorption, the drop of water into the ocean. In Christianity, with both Hebraic and Greek thought behind it, individuality is not obliterated but is consciously in relationship with God. That kind of relationship with ultimate reality leads to a different understanding of life and requires a different type of personality from the one that is seeking absorption."[21] This is clearly an important statement about De Staebler's art as well as understanding of religion, as he acknowledges when he states, immediately afterwards, "You sensed that in my work there is a tension between separateness and fusion," an effort "to keep them in an equilibrium" and show them "working simultaneously."[22]

De Staebler establishes a female relationship with clay — archaic psychic absorption in it — while keeping it separate by a male act of shaping it. He wants a completely unconscious and completely conscious relationship with clay, with a breathless simultaneity that is the measure of his extraordinary ambition. It is worth noting that, in his mystical dialectical feeling towards clay — his female, Eastern desire to surrender himself completely to or disappear in its process but also, in a Western, masculine way, to stand back from it and see it in the final sculptural product he has made of it — he describes his ambivalent relationship to it in the language such psychoanalysts as Margaret Mahler and D. W. Winnicott use to describe the child's psyche. He "must continually reconcile his longing for independent autonomous existence with an equally powerful urge to surrender and reimmerse himself in the enveloping [maternal] fusion from which he has come."[23] This longing for independent autonomous existence can be connected with Jung's idea of individuation as the "process of differentiating the self" from the other aspects of the personality, including the collective unconscious.[24] In De Staebler's figural sculpture we are witness

to the still incomplete process of individuation, in which a self emerges from a symbiotic union with all-absorbing Mother Earth and comes into its own in and through its autonomous products. De Staebler's figures seem to be simultaneously differentiated from yet fused with clay — another example of his equilibration of opposites. There is spiritual pain in this equilibrium, for it implies De Staebler's self is trapped at a cross-roads. Nonetheless, the equivocal character of De Staebler's figure — which is part of its archaism — makes clear the eschatological character of his art. In the stroke of a single figure it articulates the first and last things of human being, the mystery of a being who remains strongly bound to its regressive origin in primal matter while asserting its spiritual pride, if in a fragmentary way.

NOTES

[1] Stephen De Staebler and Diane Apostolos-Cappadona, "Reflections on Art and the Spirit: A Conversation," in *Art, Creativity, and the Sacred: An Anthology in Religion and Art*, ed. Diane Apostolos-Cappadona (New York, Crossroad, 1984), pp. 27-28. Henceforth "Conversation."

[2] Ibid., p. 32.

[3] Ibid., p. 33.

[4] Quoted by Ted Lindberg, "Stephen De Staebler," *Stephen De Staebler* (Vancouver, Emily Carr College of Art and Design, 1983; exhibition catalogue), p. 7.

[5] Quoted in ibid., p. 6.

[6] Stephen De Staebler, "Keynote Address," *NCECA Journal*, 5 (1984): 10. Henceforth "Keynote Address."

[7] Ibid.

[8] Ibid.

[9] Ibid., p. 9.

[10] Erich Fromm has argued, in *The Crisis of Psychoanalysis* (Greenwich, Conn., Fawcett Premier Books, 1971), pp. 191-92, that "the most fundamental [contemporary] problem … is the opposition between the love of life (biophilia) and the love of death (necrophilia): not as two parallel biological tendencies, but as alternatives: biophilia as the biologically normal love of life, and necrophilia as its pathological perversion, the love of and affinity to death."

[11] Keynote Address, p. 9.

[12] Ludwig von Bertalanffy has pointed out, in *General System Theory* (New York, George Braziller, 1975), p. 191, that "'man as robot' was both expression and motor force of the *zeitgeist* of a mechanized and commercialized society; it helped to make psychology the handmaiden of pecuniary and political interests. It is the goal of manipulating psychology to make humans ever more into robots or automata, this being engineered by mechanized learning, advertising techniques, mass media, motivation research and brainwashing…. The image of man as robot is metaphysics or myth, and its persuasiveness rests only in the fact that it so closely corresponds to the mythology of mass society, the glorification of the machine, and the profit motive as sole motor of progress." Psychologically understood, De Staebler's archaic figures are the rebellious antithesis of the engineered human. In their unslickness, they are antimechanistic and anticapitalistic, and an assertion that technological progress is a delusion hiding the lack of human progress, that is, the absence of fundamental change in man's primitive psychic condition, or the lack of advance towards a binding civilized condition. De Staebler's figures remind us that however much life has been externally transformed it remains internally untransformed, although external changes take their toil on internal life, particularly when they assert that it can be as much of a "brave, new world" as mechanistic, capitalistic society.

[13] Conversation, p. 25.

[14] C.G. Jung, *Two Essays on Analytical Psychology* (New York, Pantheon Books, 1953; Bollingen Series), p. 65.

[15] C.G. Jung, *The Practice of Psychotherapy* (New York, Pantheon Books, 1954; Bollingen Series), p. 34.

[16] C.G. Jung, *The Spirit in Man, Art, and Literature* (New York, Pantheon Books, 1966; Bollingen Series), p. 81.

[17] For a discussion of the notion of the expressionist cry see my essay on "Chaos in Expressionism," *Psychoanalytic Perspectives on Art*, ed. Mary Mathews Gedo (Hillside, N.J., Analytic Press, 1985), pp. 61-71. I believe the idea of the work of art as an outcry informs Expressionism, explaining its so-called "distortion" of reality.

[18] Conversation, p. 29.

[19] Jung, *The Practice of Psychotherapy*, p. 77.

[20] Conversation, p. 26.

[21] Ibid., pp. 28-29.

[22] Ibid., p. 29.

[23] Jay R. Greenberg and Stephen A. Mitchell, *Object Relations in Psychoanalytic Theory* (Cambridge, Mass., Harvard University Press, 1983), pp. 272-73.

[24] C.G. Jung, *Psychological Types* (New York, Harcourt, Brace & Co., 1946), p. 561.

COLOR PLATES

32

1. *Seated Woman with Outstretched Hand*, 1984

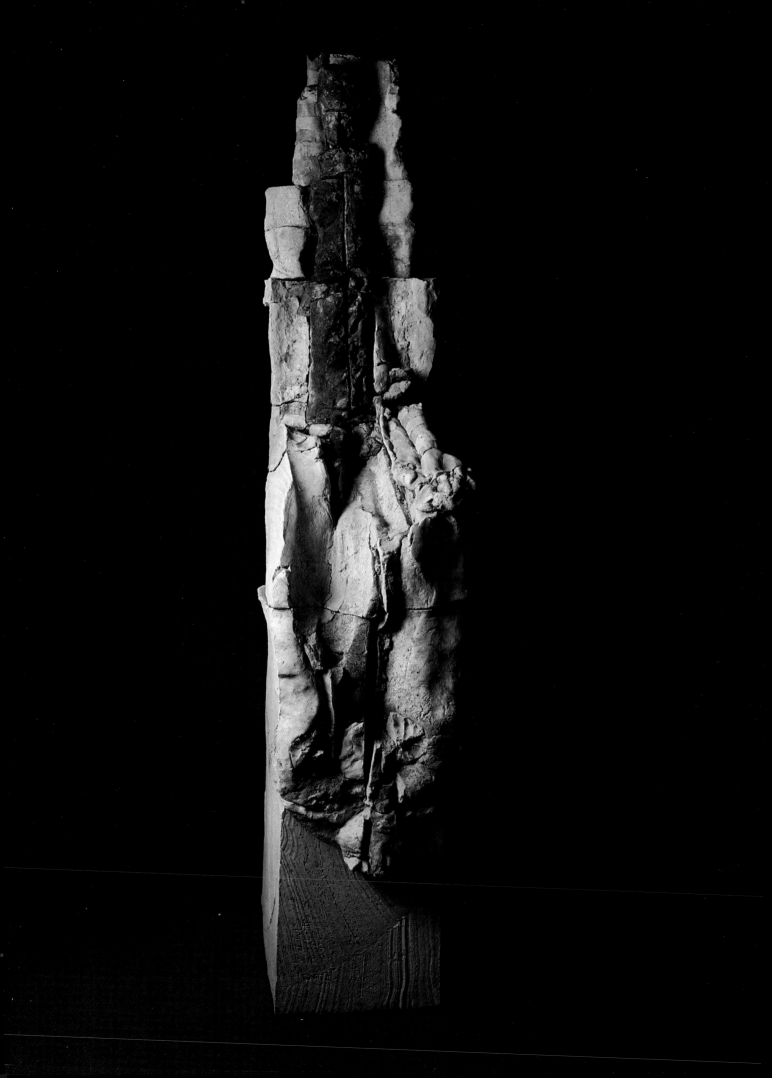

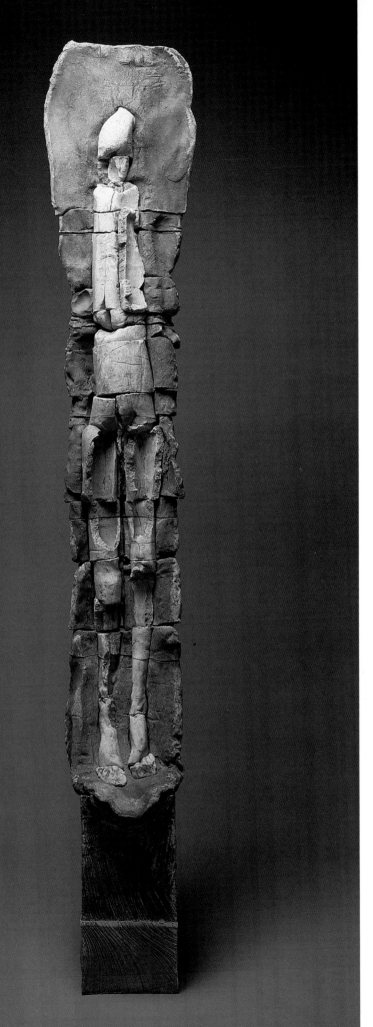

2. *Standing Figure with Dark Aura*, 1984

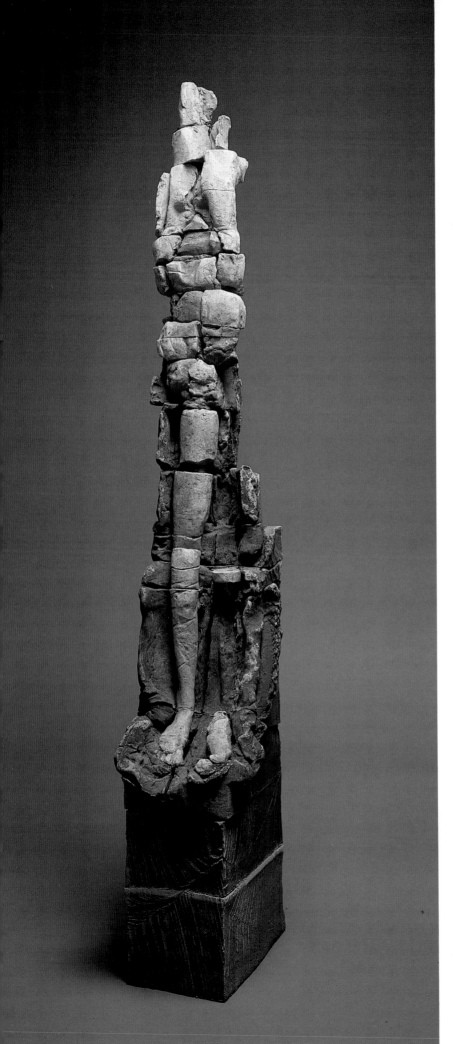

3. *Standing Figure with Flattened Torso*, 1984

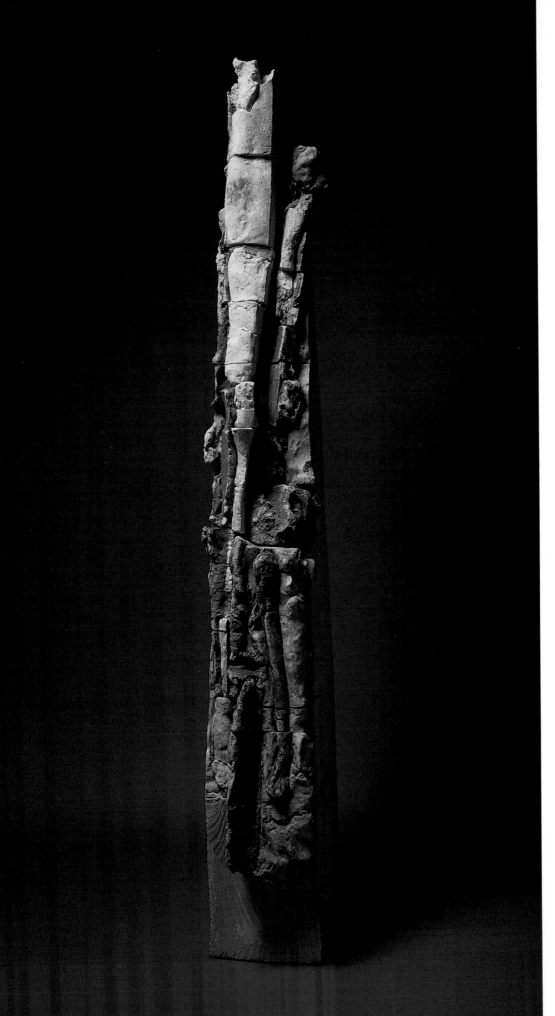

4. *Standing Figure with Segmented Torso,*
1985

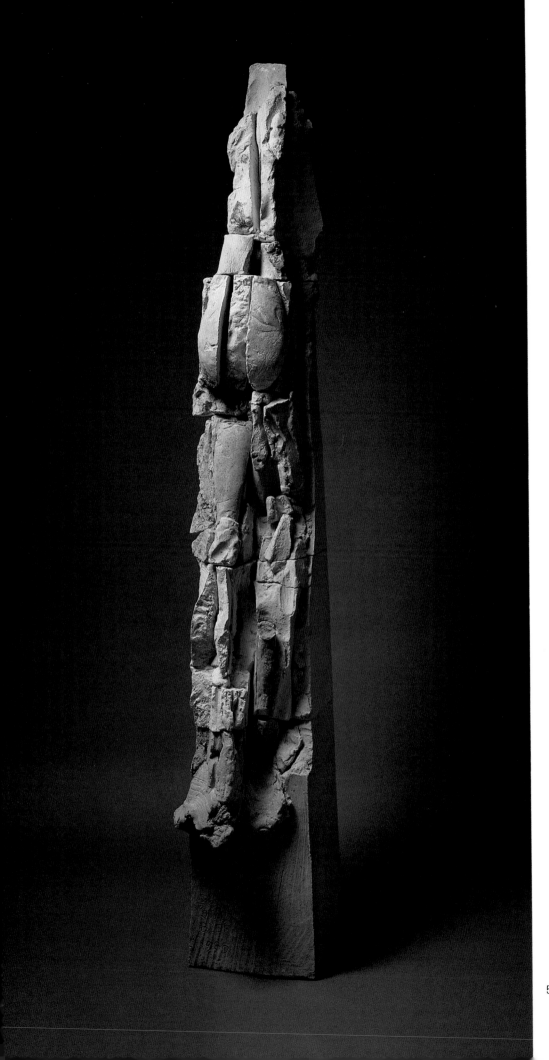

5. *Wedged Woman Standing*, 1985

38

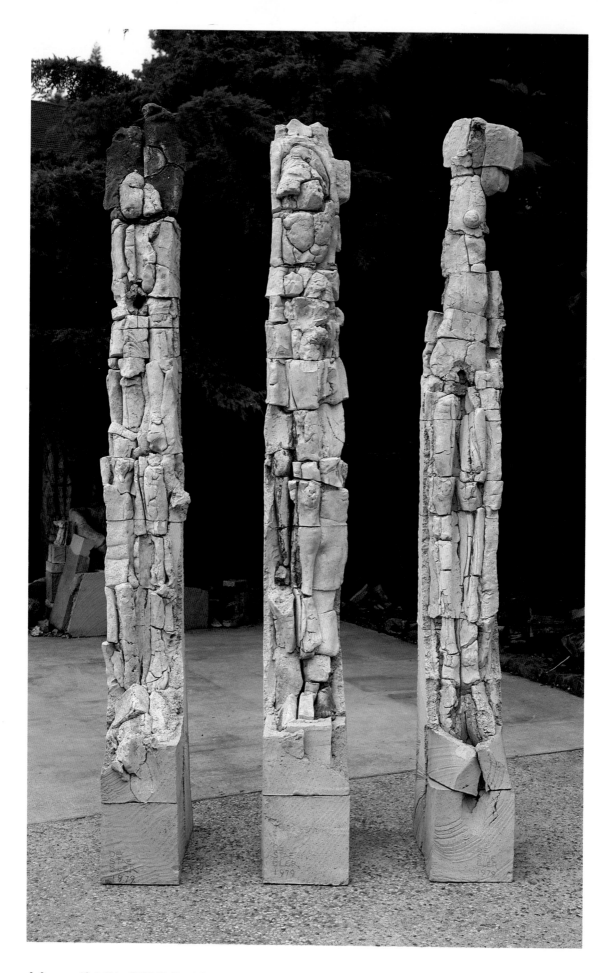

6. *Compressed Stele Rising*, 1979 (left); *Phoenix Stele*, 1979 (center); and *Standing Woman with Twisting Torso*, 1979 (right)

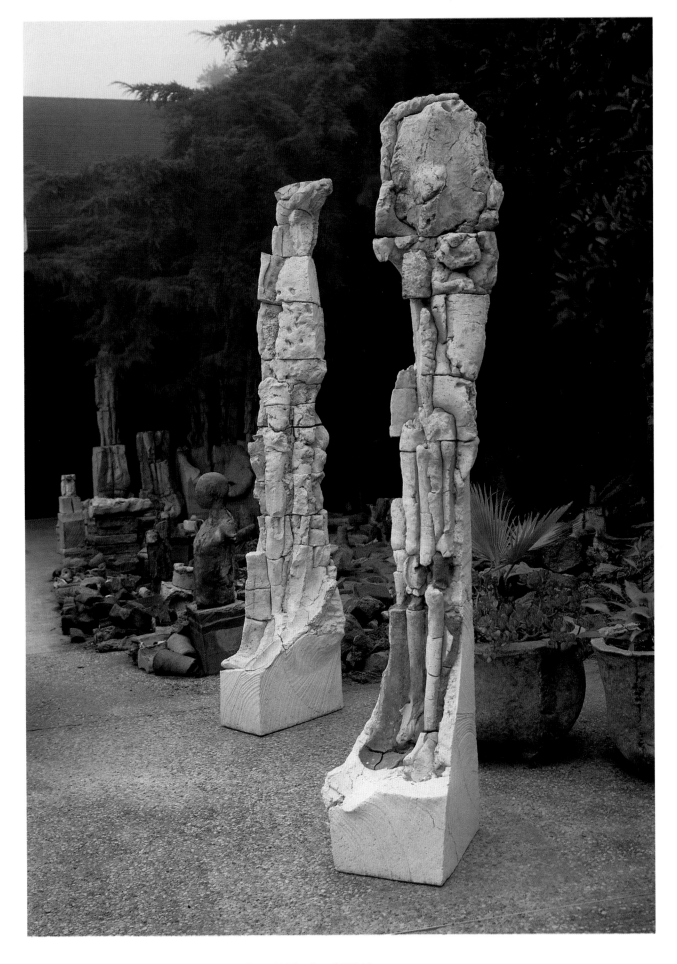

7. *Standing Figure with Tilting Head*, 1985 (left), and *Standing Figure with Yellow Aura*, 1985 (right)

8. *Seated Figure with Striped Right Arm*, 1984 (left), and *Seated Figure with Yellow Flame*, 1985 (right)

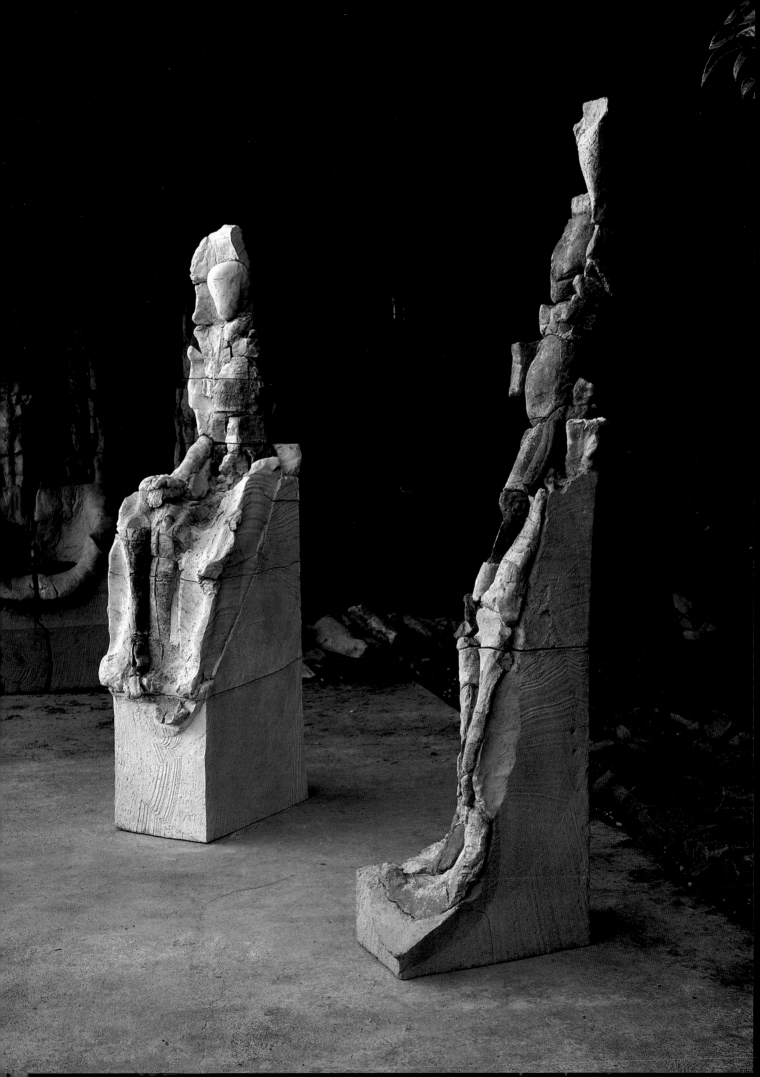

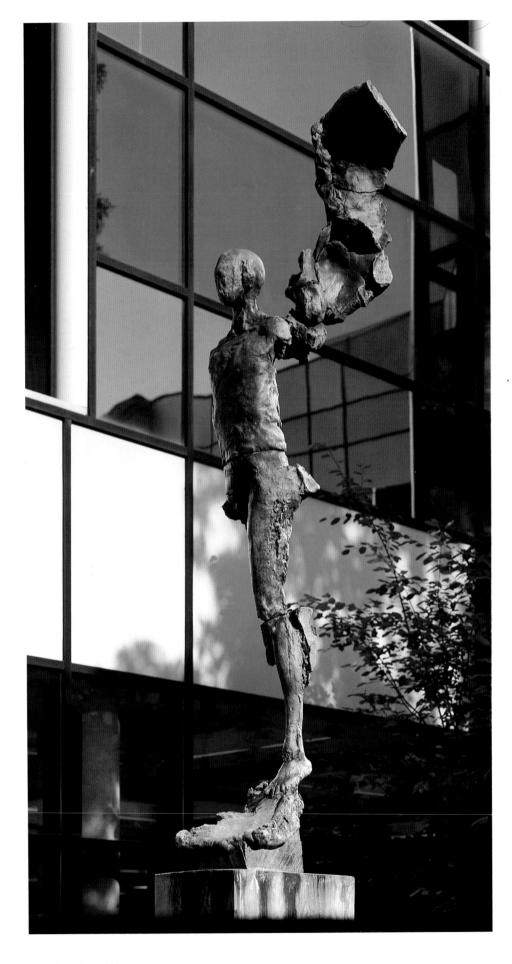

9. *Left-Sided Angel*, 1986

44

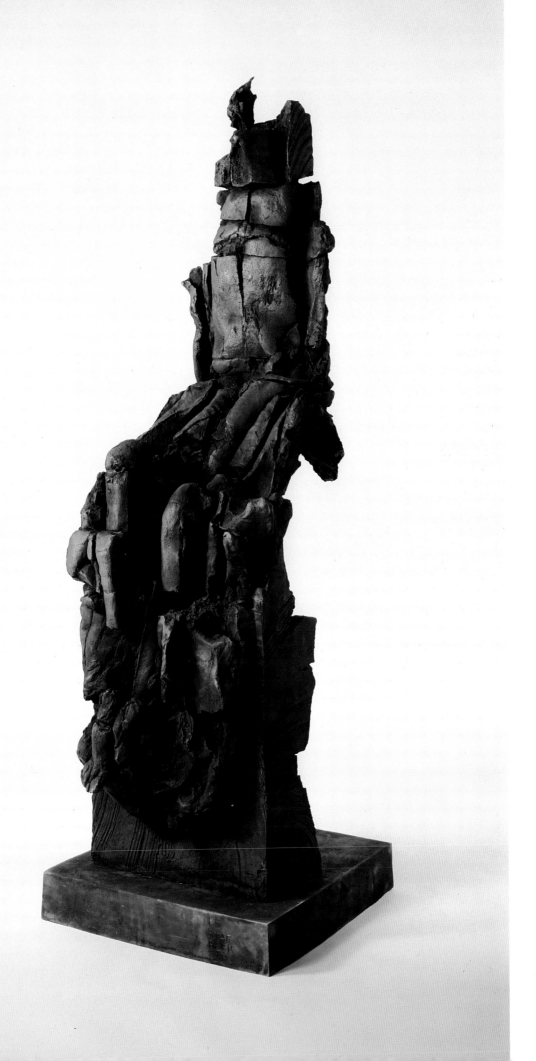

46

11. *Seated Woman Bisected*, 1981

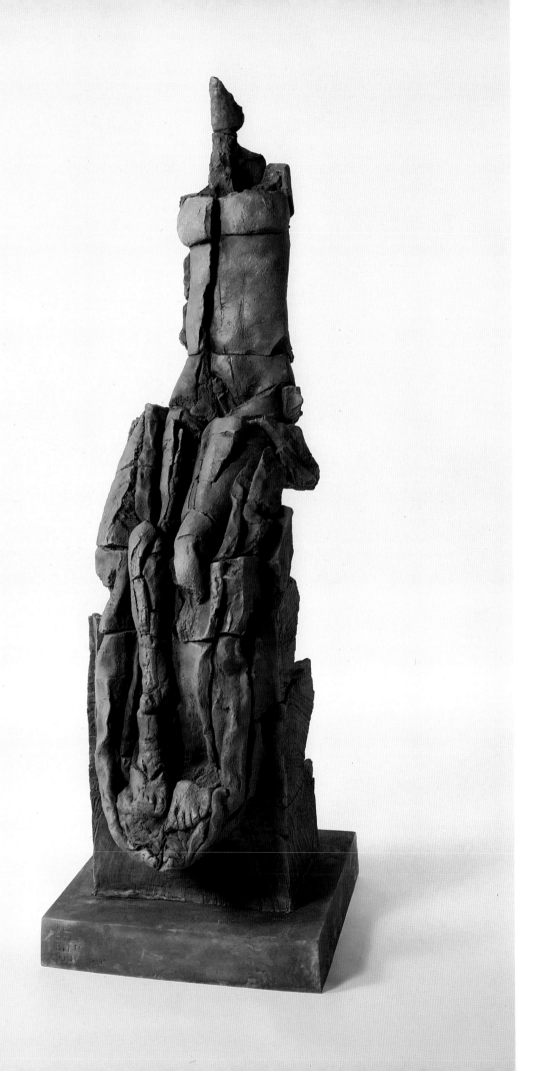

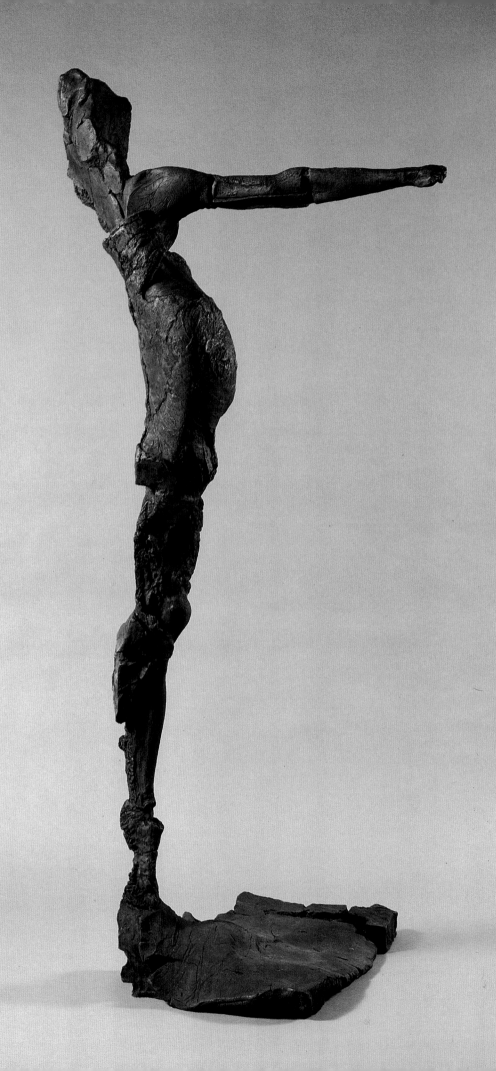

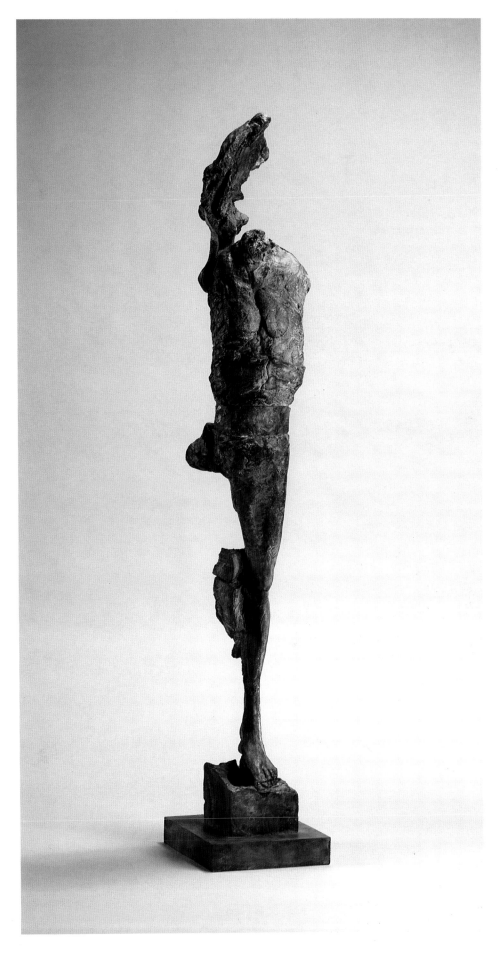

12. *Left-Sided Figure Pointing*, 1983

13. *Winged Woman*, 1986

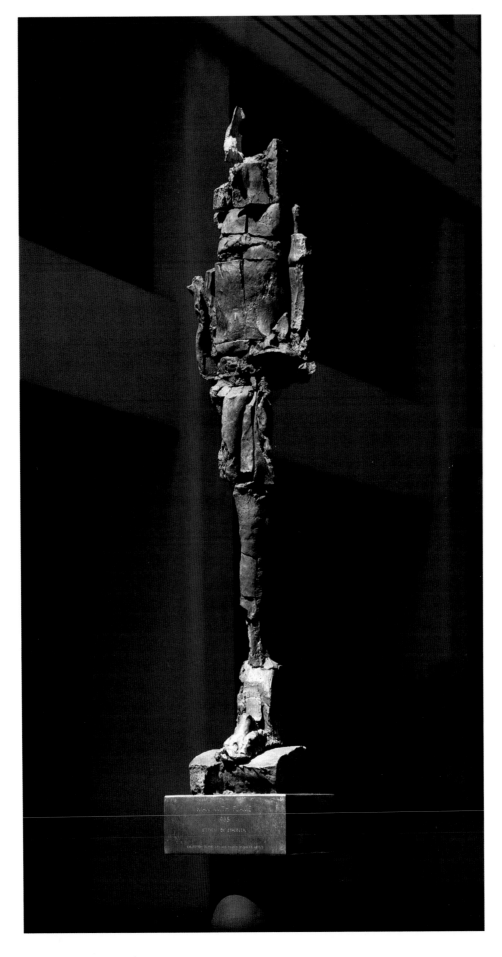

14. *Man with Flame*, 1985

15. *Pregnant Woman*, 1982

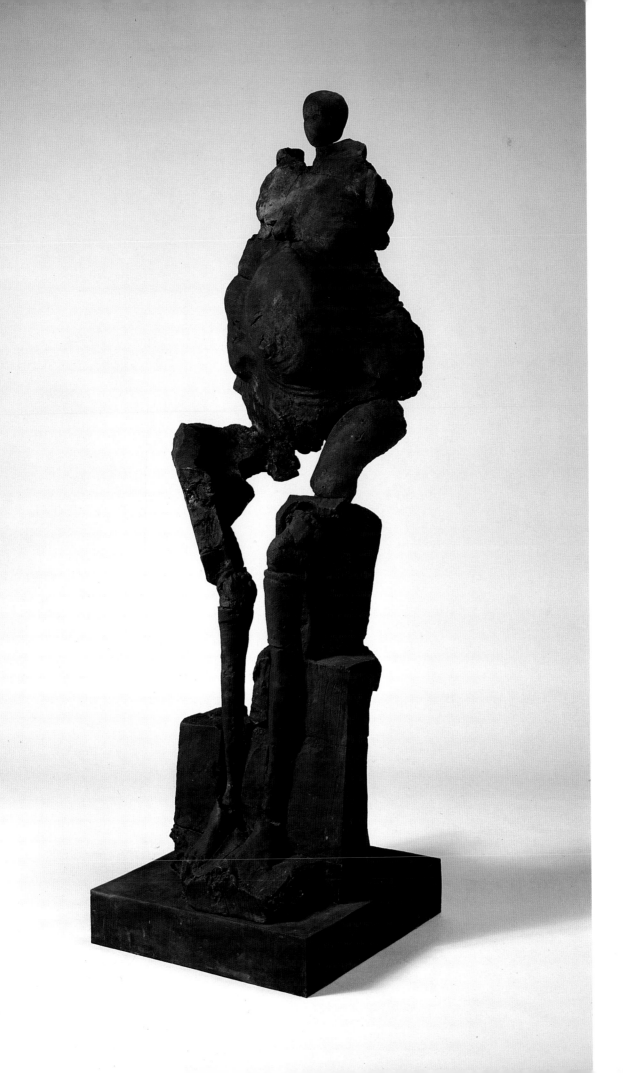

54

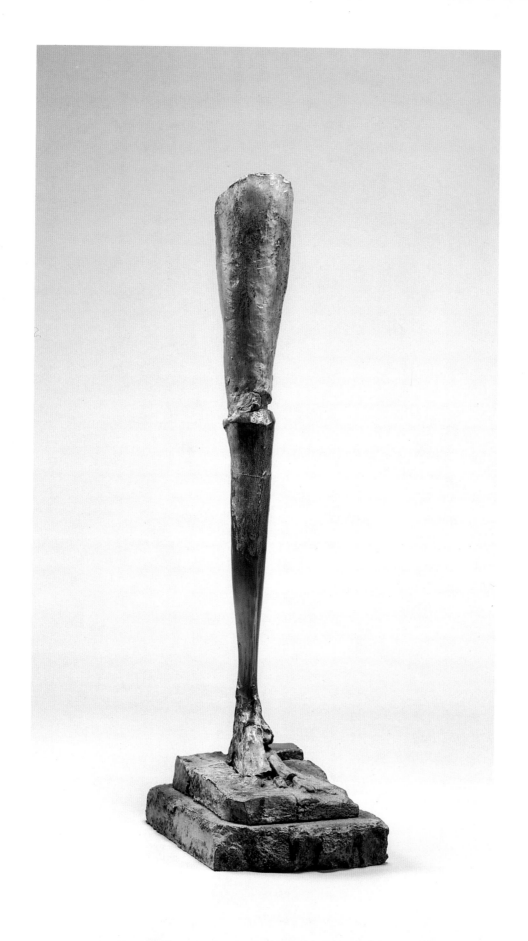

16. *Leg VIII*, 1981

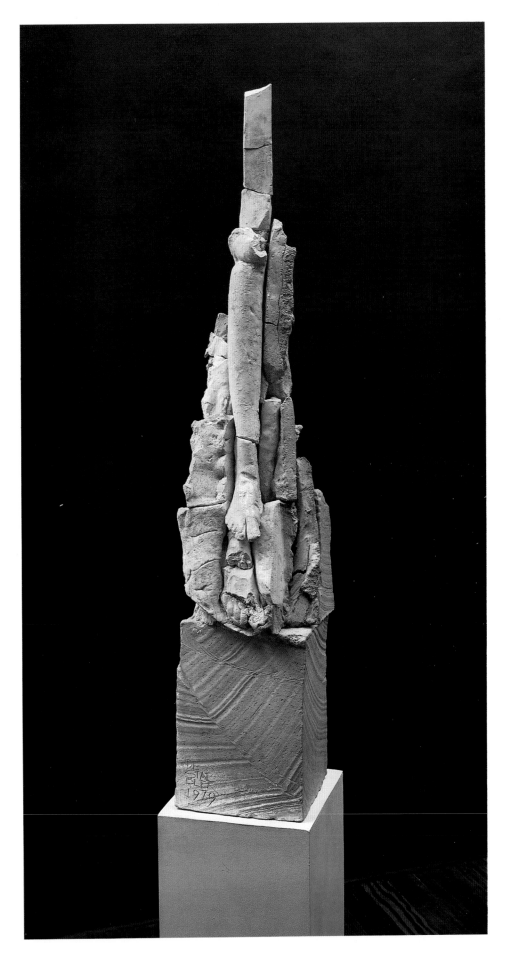

17. *Lavender Leg with Double Foot*, 1979

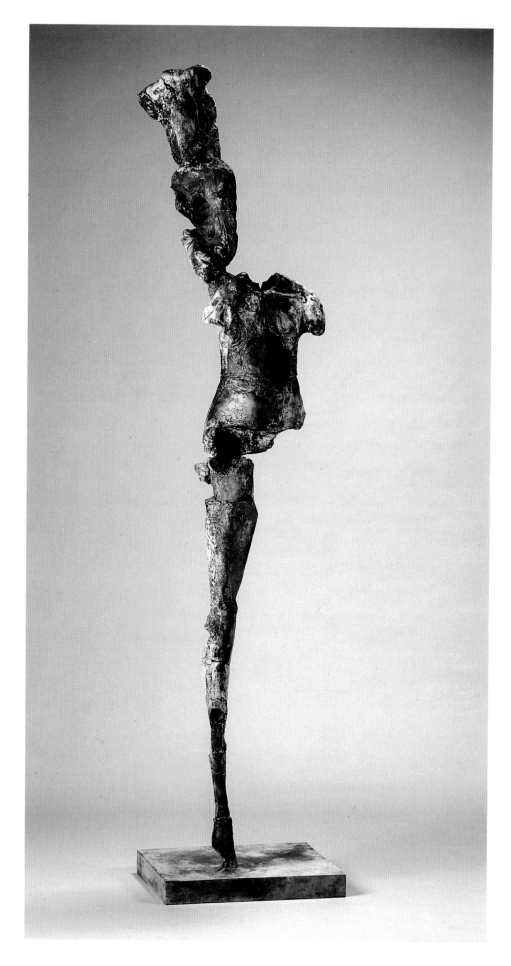

18. *Right-Sided Angel*, 1986

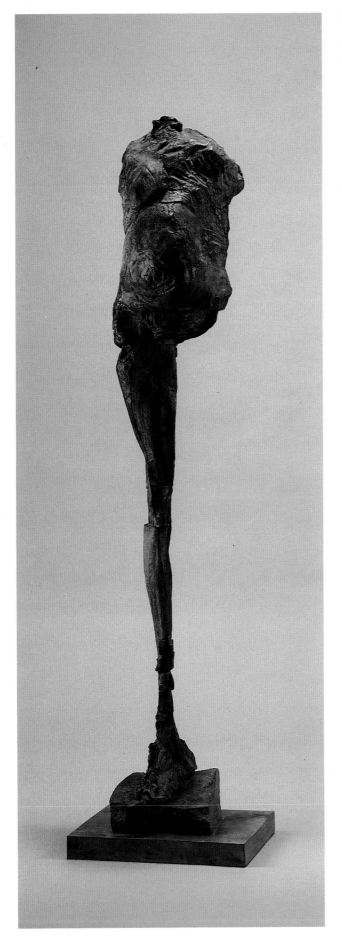

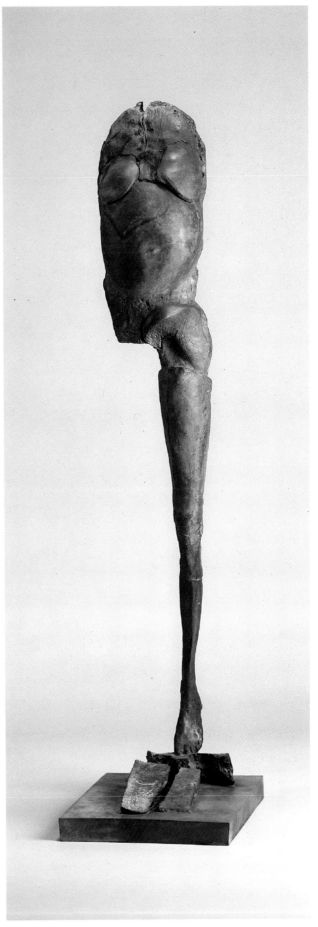

19. *Pregnant Woman II*, 1986

20. *Pregnant Woman IV*, 1986

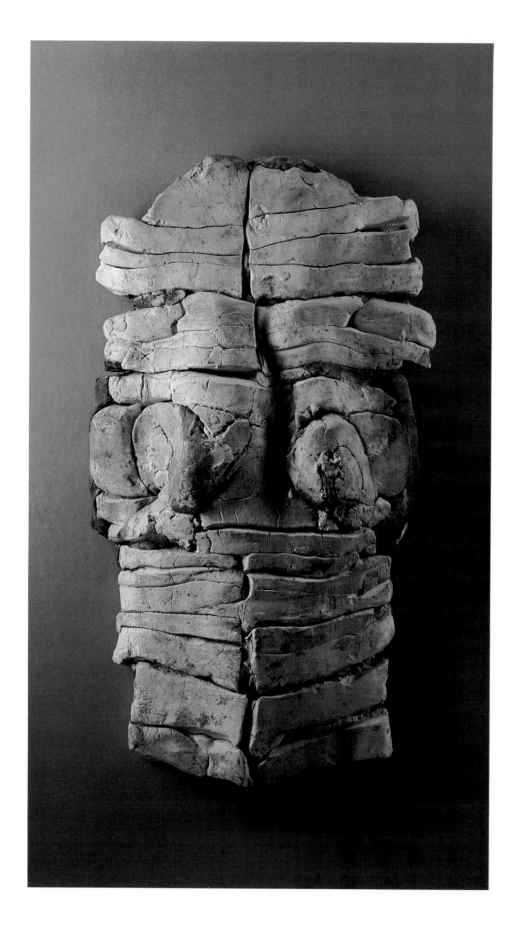

21. *Pressed-Breast Torso*, 1976

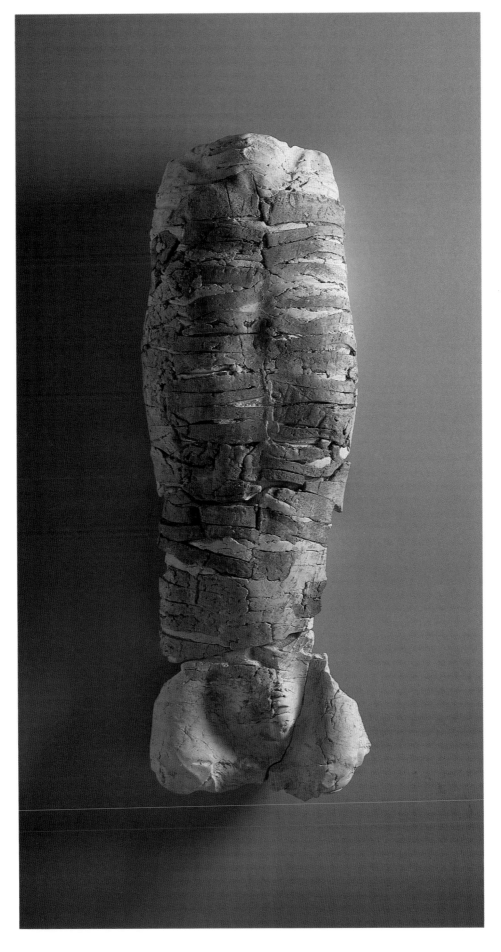

22. *Wall Torso I*, 1983

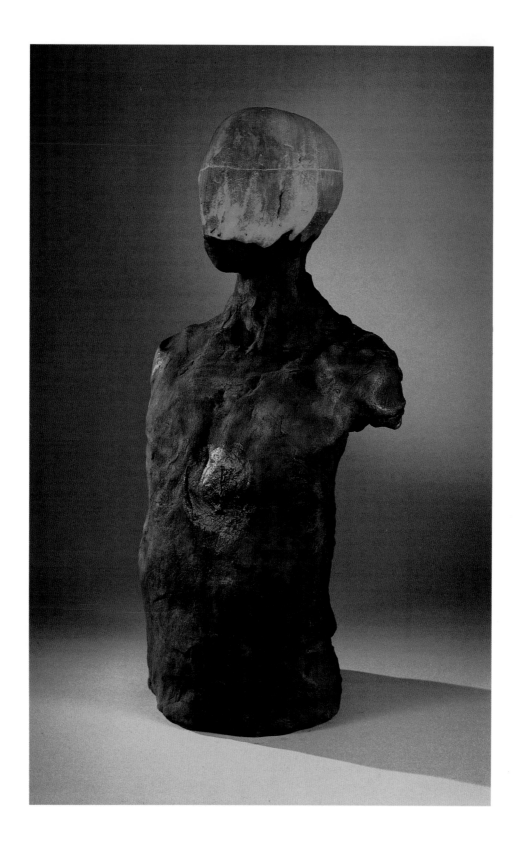

23. *Man with Tar Heart*, 1981

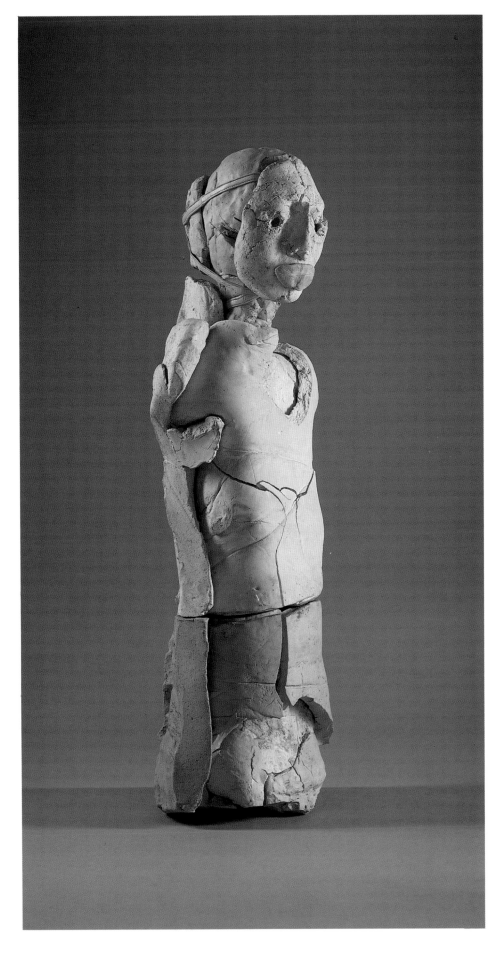

24. *Lavender Torso with Mask*, 1976/1985

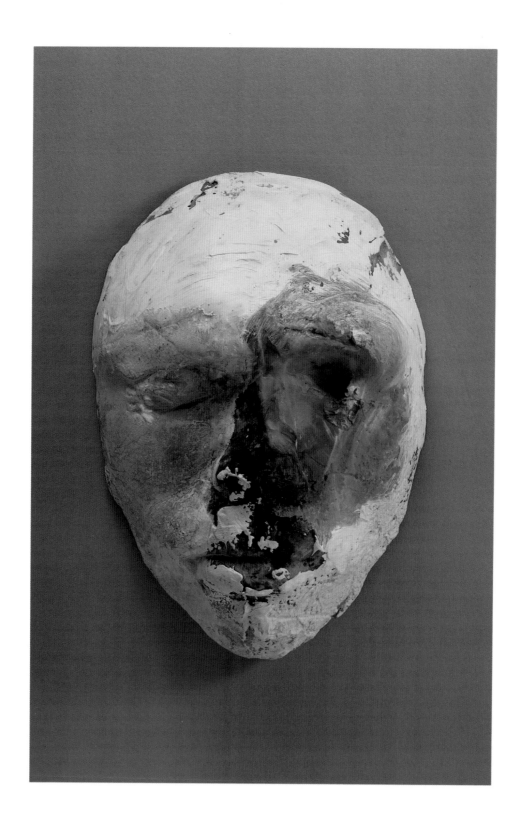

25. *Face with Blue Eye*, 1982

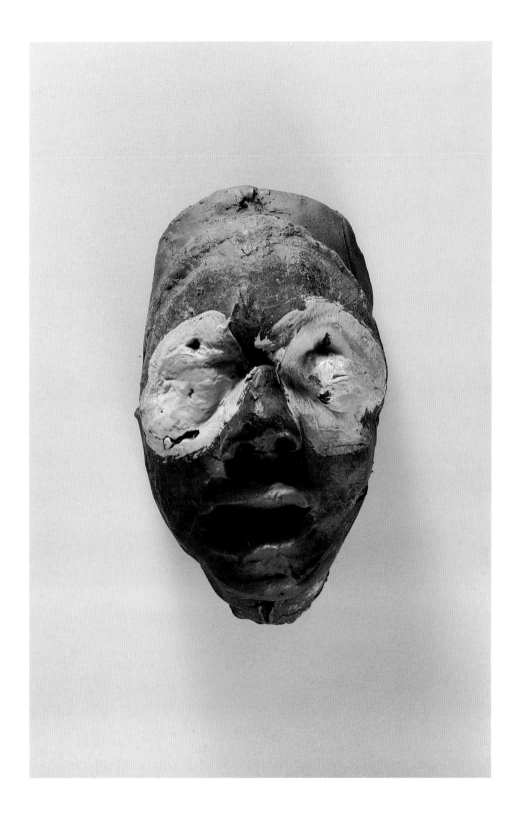

26. *Man with Melting Mouth*, 1966/1981

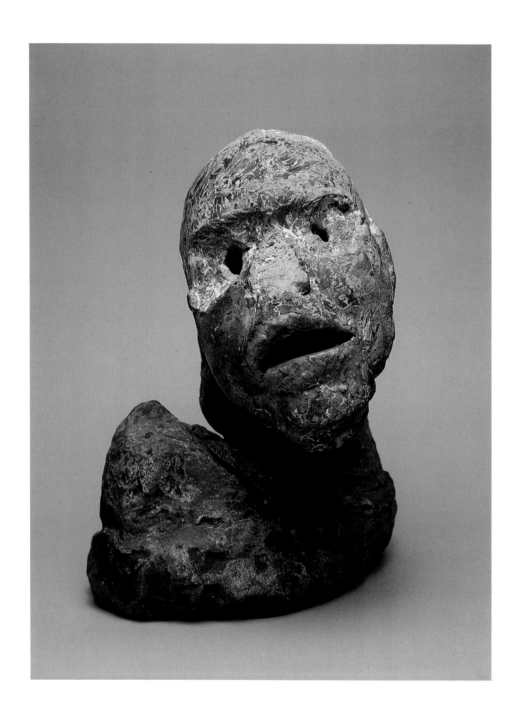

27. *Head with Mask*, 1972/1983

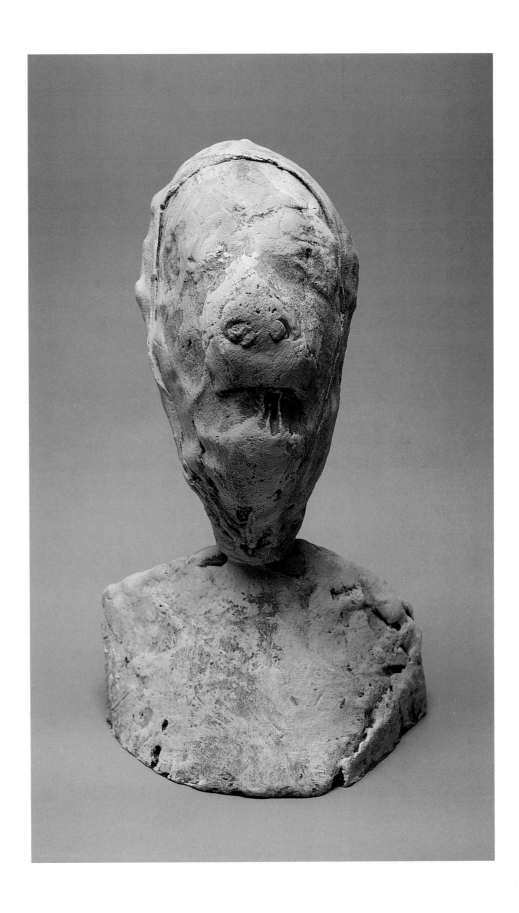

28. *Head with Bated Breath*, 1983

66

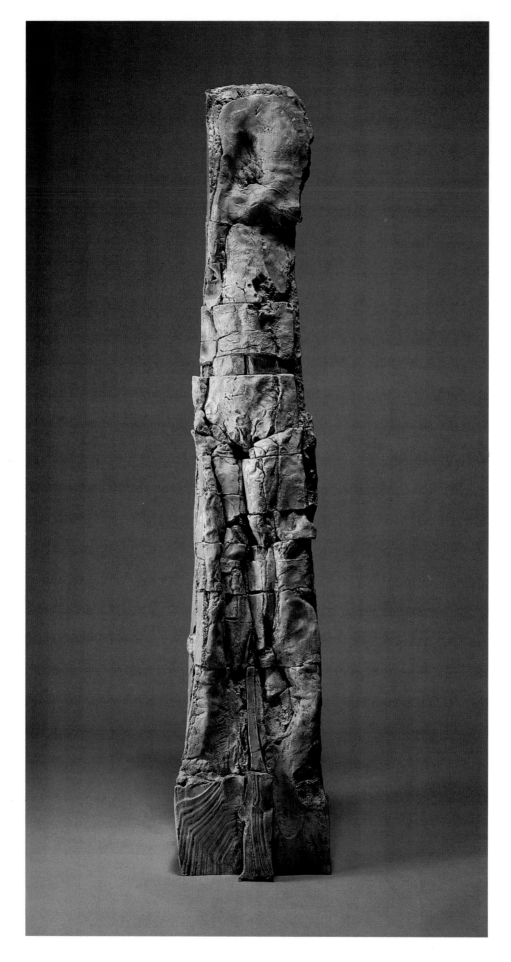

29. *Wedged Man Standing II*, 1981

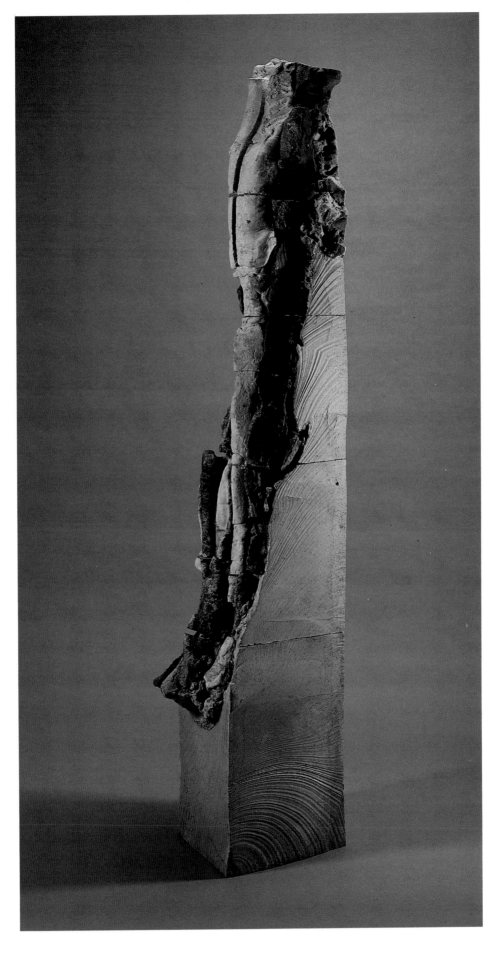

30. *Standing Figure with Quartered Torso*, 1985

68

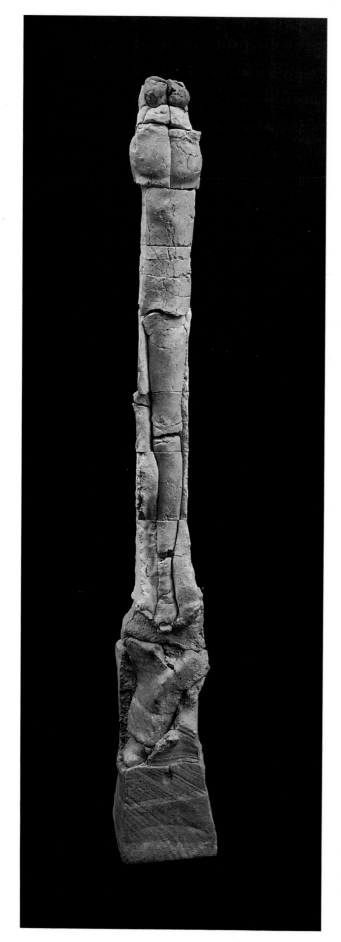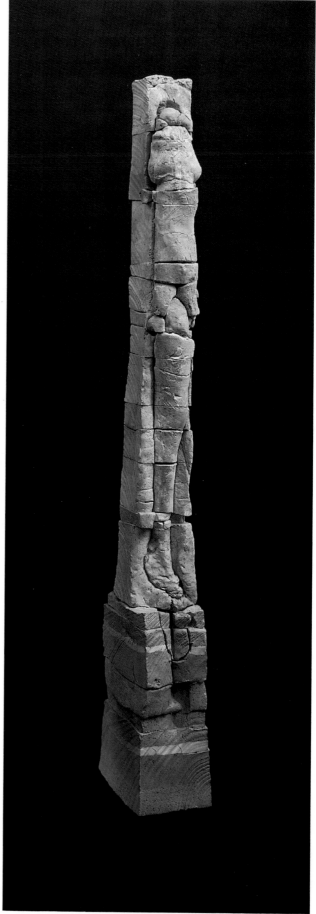

31. *Lavender Figure Column*, 1979 (left), and *Lavender Figure Column with Yellow*, 1979 (right)

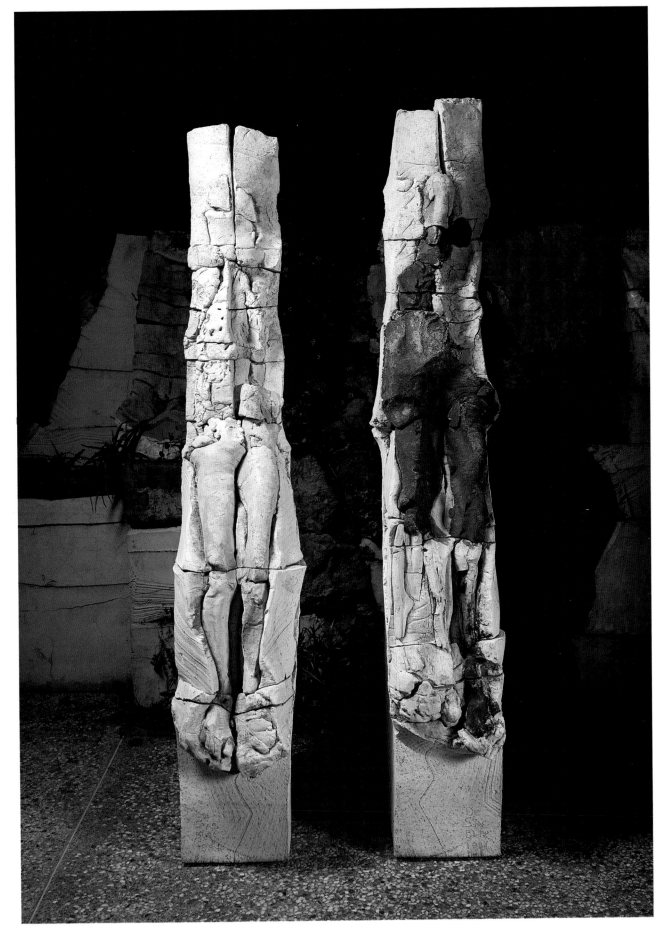

32. *Seated Figure Pale Blue*, 1984 (left), and *Seated Figure with Cleft*, 1984 (right)

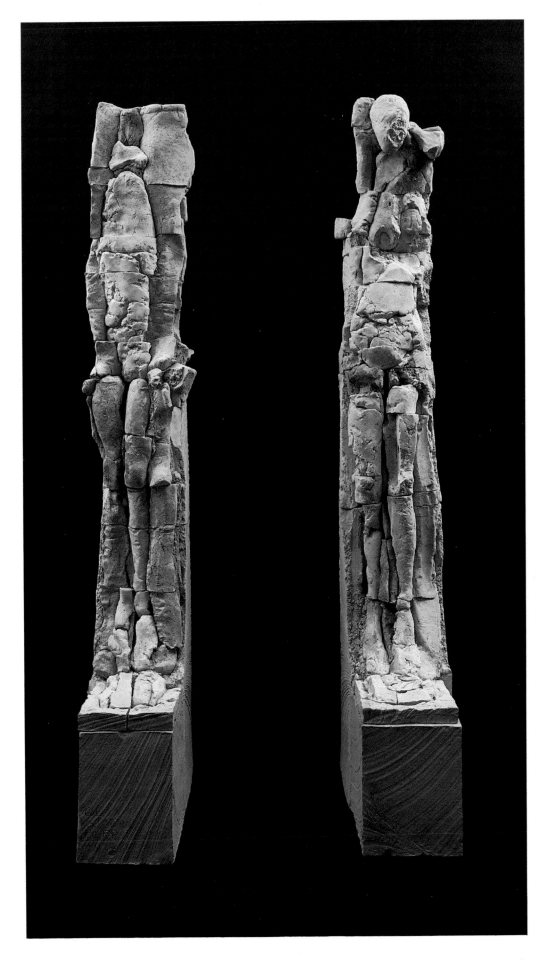

33. *Standing Figure with Bow Leg*, 1979 (left), and *Standing Woman with Yellow Breast*, 1979 (right)

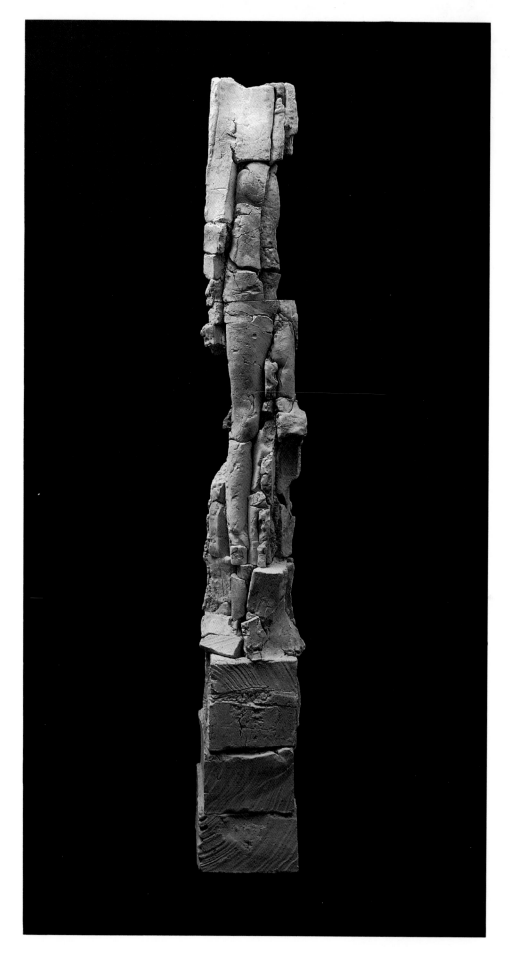

34. *Right-Sided Woman Standing*, 1979

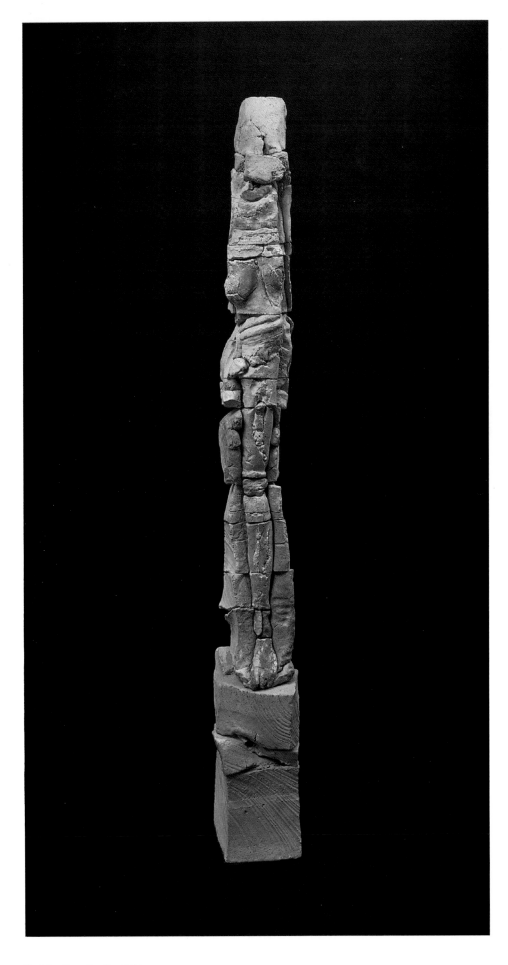

35. *Fallen Figure Standing*, 1979

36. *Standing Man with One Pink Foot*, 1978

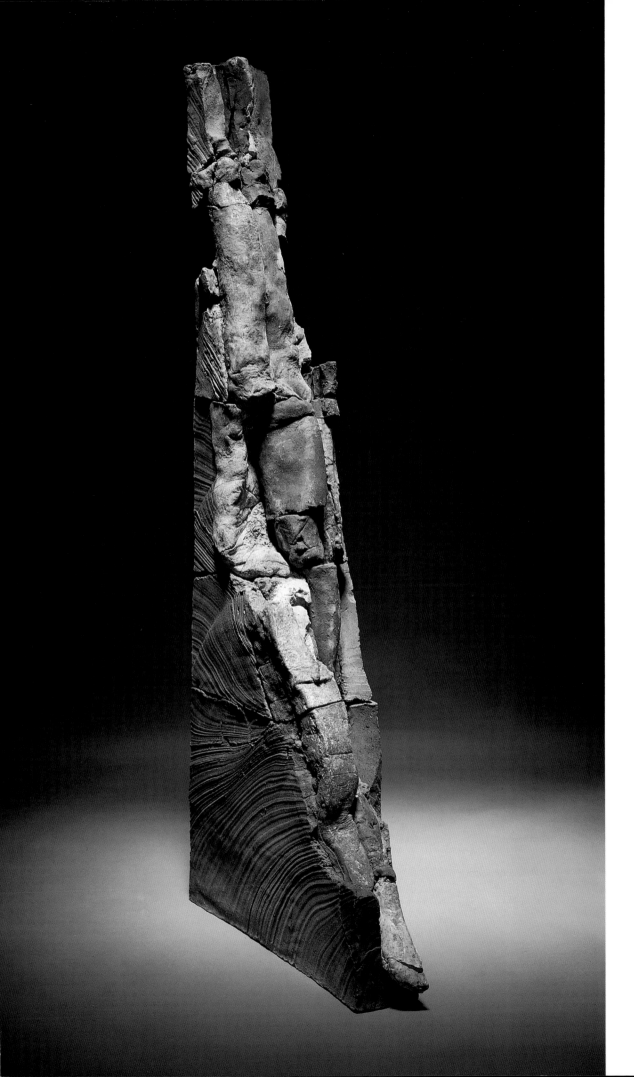

37. *Standing Figure with Swayback*, 1978

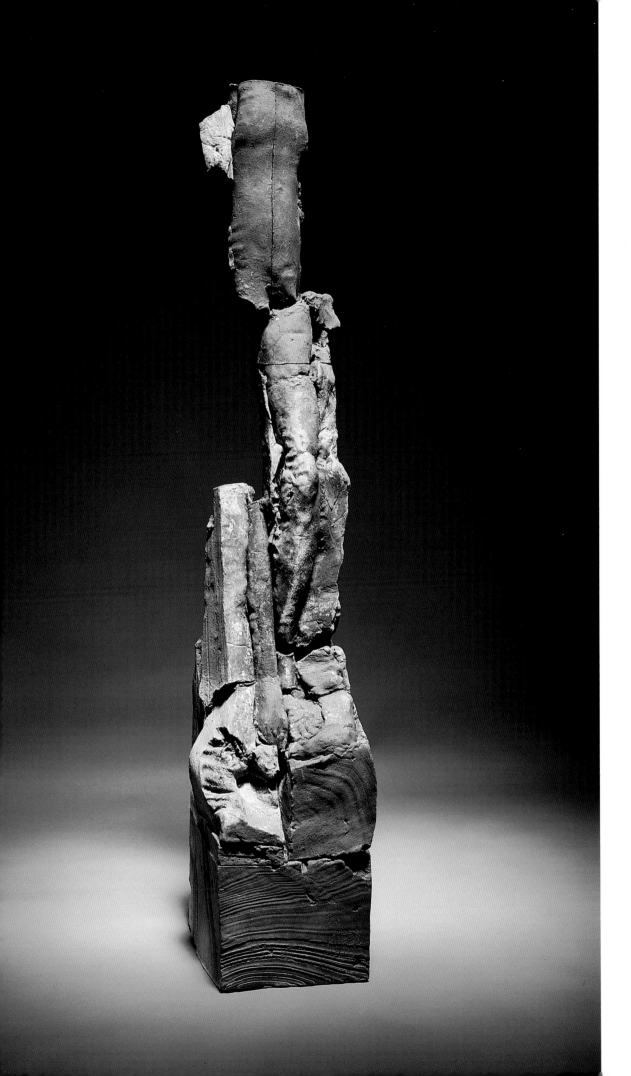

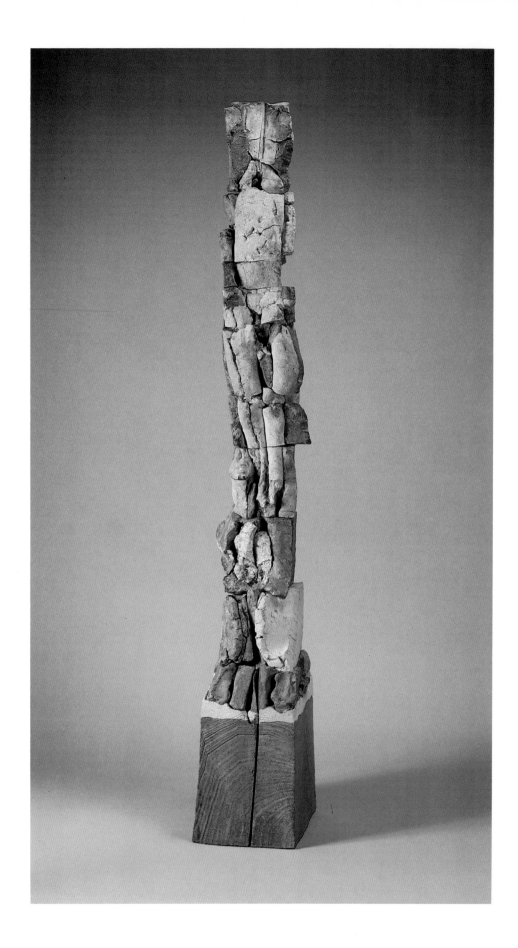

38. *Laid-Back Figure Column,* 1979

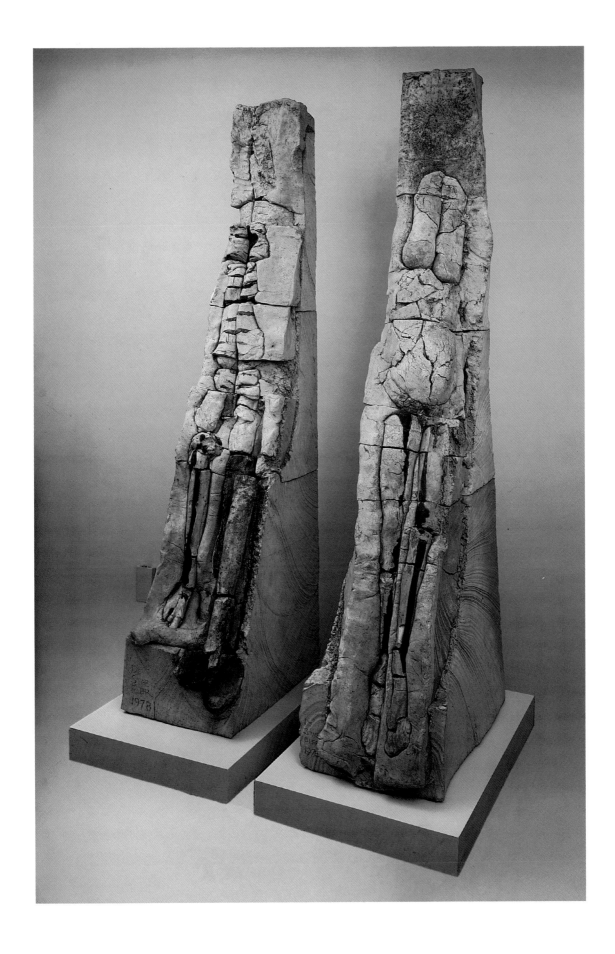

39. *Standing Figure with Ribs*, 1978 (left), and *Standing Woman with Missing Hip*, 1978 (right)

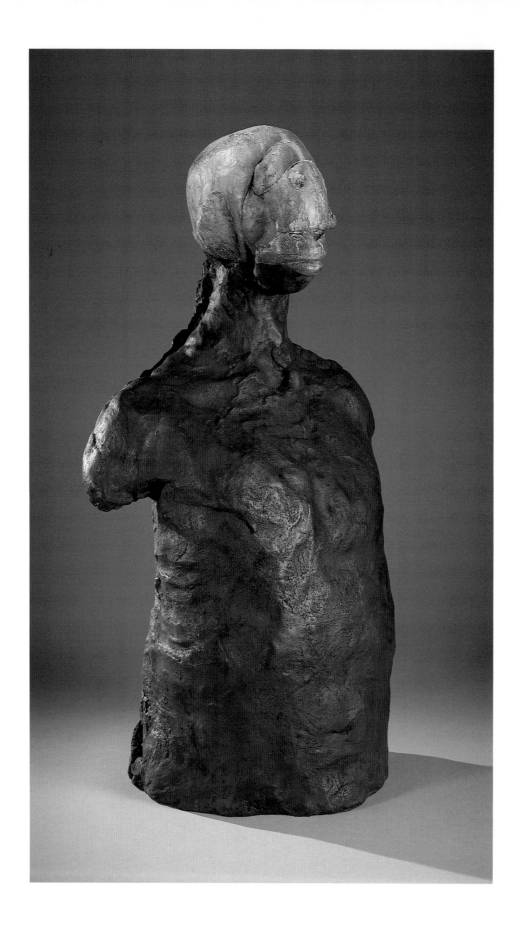

40. *Man with Lip-Eye*, 1981

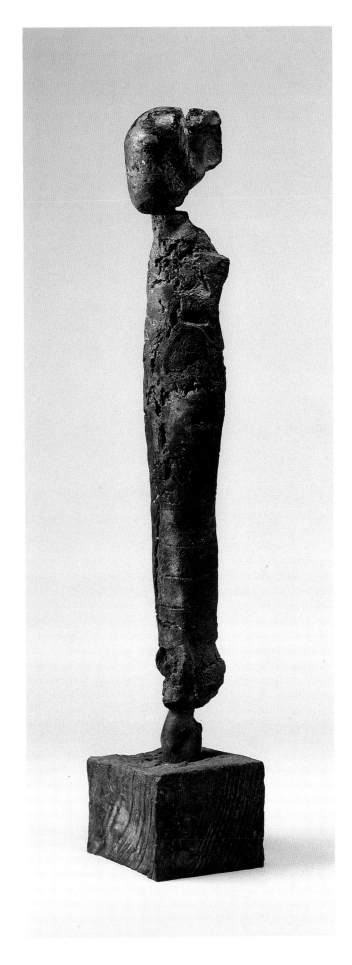

41. *Blue Torso Column*, 1984

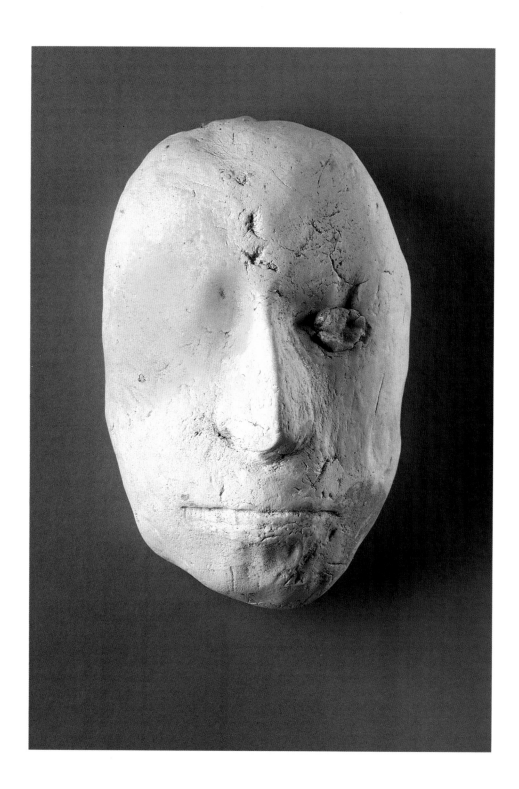

42. *Yellow Eye/Blue Eye*, 1973

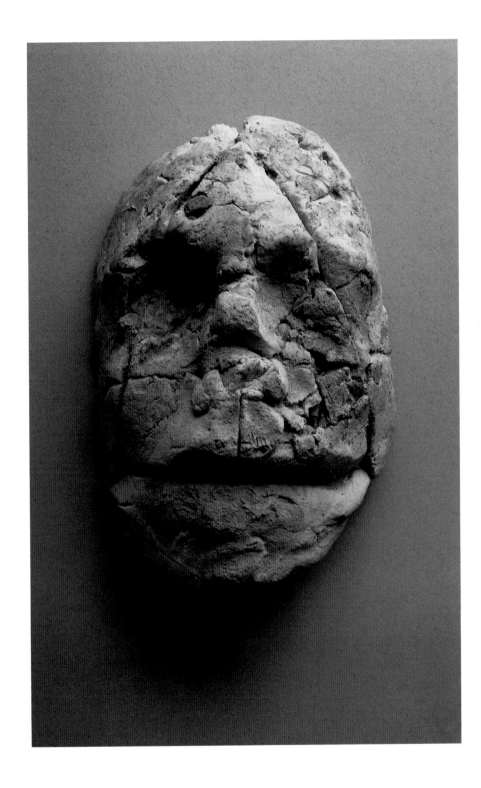

43. *Lavender Face with Missing Eye*, 1976

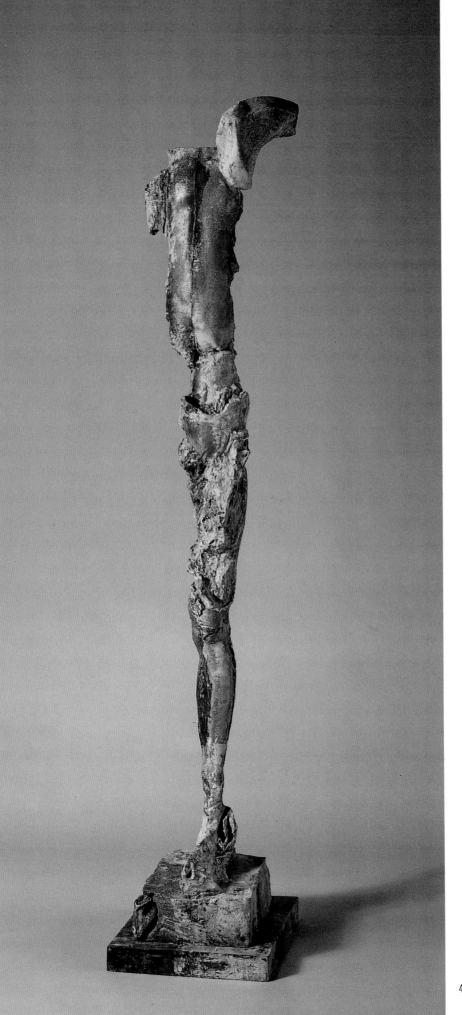

44. *Standing Figure with Blue Shoulder*, 1983

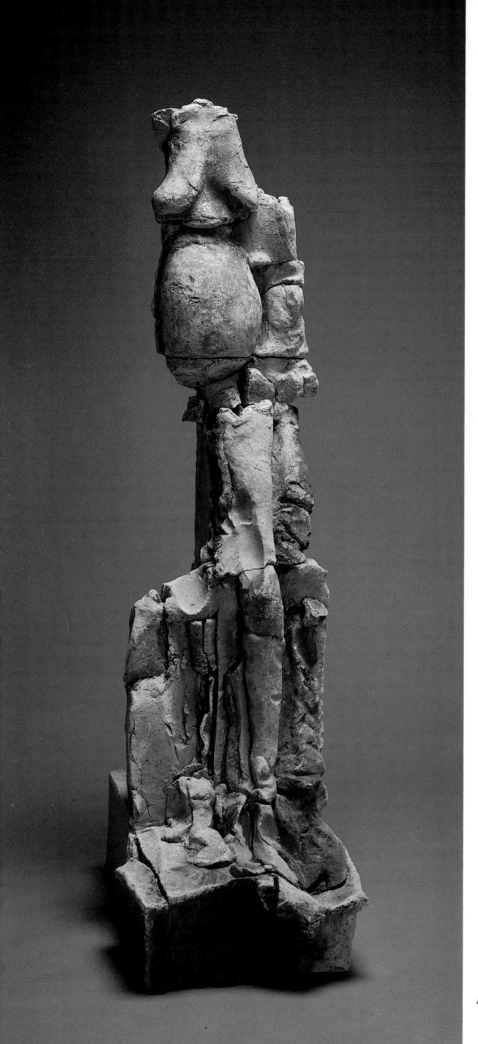

45. *Seated Woman with Left Leg*, 1985

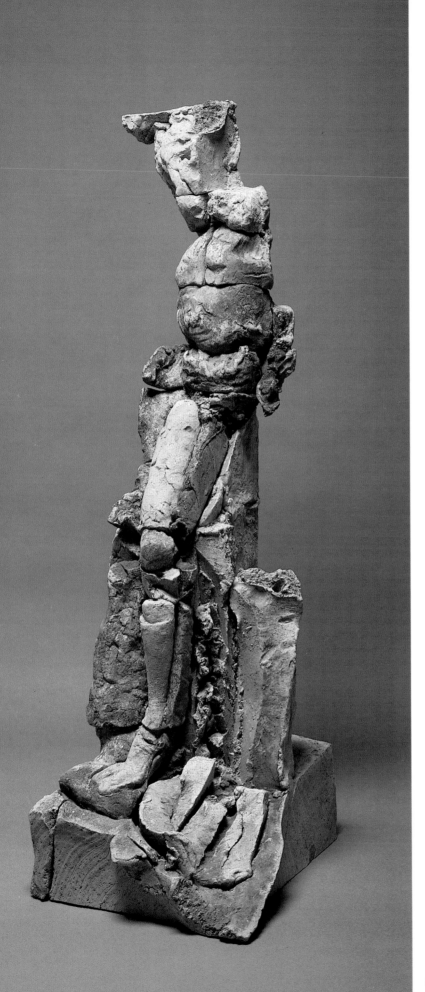

46. *Right-Sided Woman Sitting*, 1985

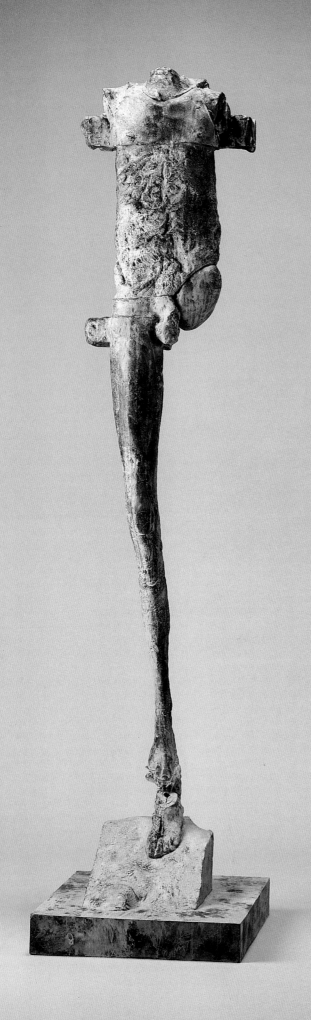

47. *Standing Man with Stone*, 1986

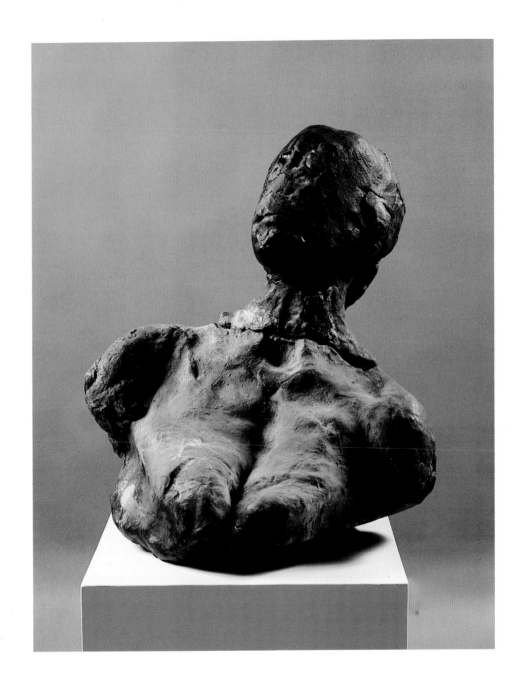

48. *Female Torso*, 1981

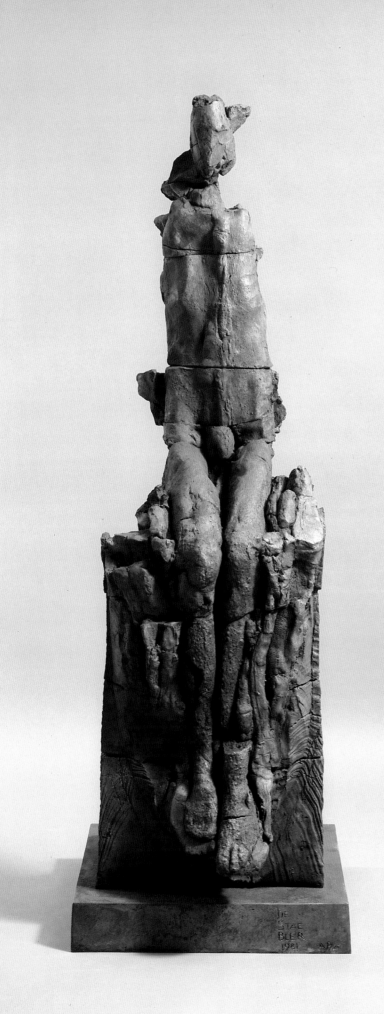

49. *Seated Man with Winged Head*, 1981

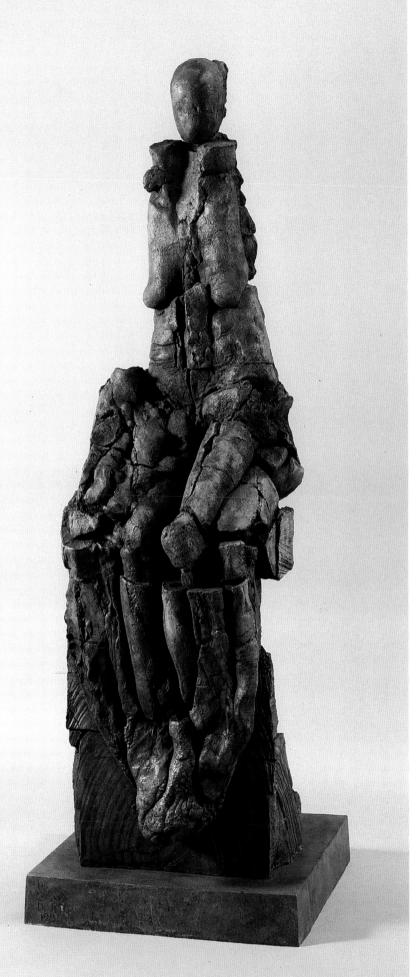

50. *Seated Woman with Oval Head*, 1981

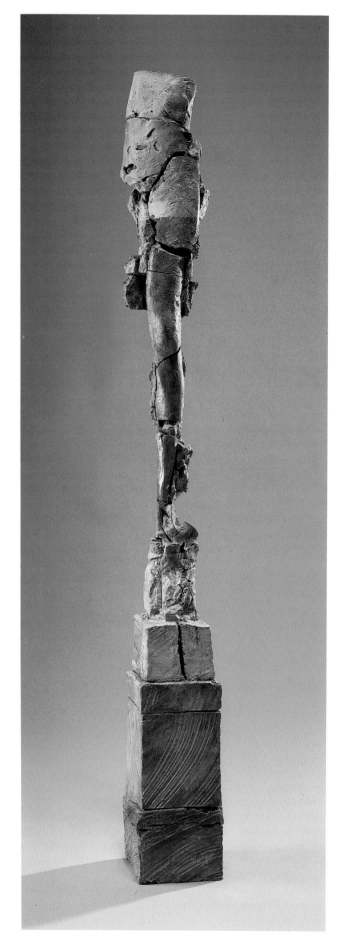

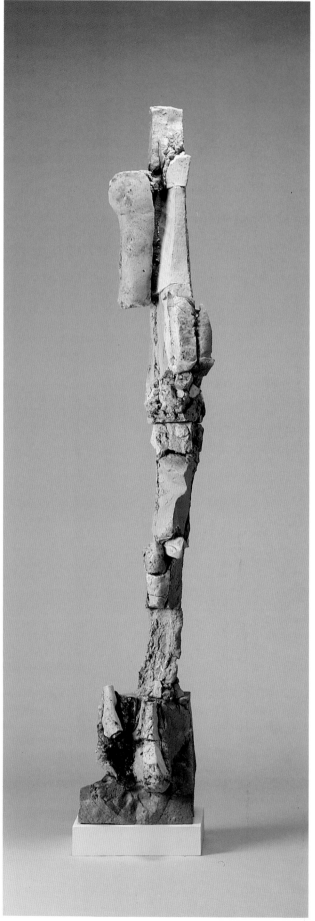

51. *Left-Sided Figure Standing*, 1981

52. *Double Torso on One Leg*, 1985

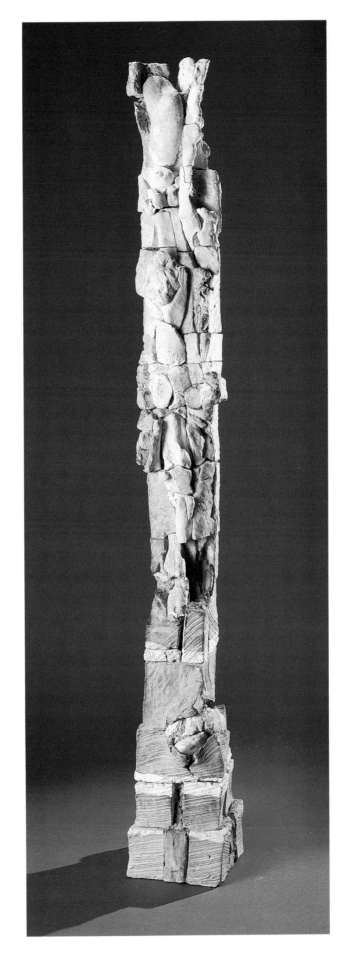

53. *Cleft Stele*, 1979

54. *Standing Woman*, 1975 (left), and *Standing Man*, 1975 (right)

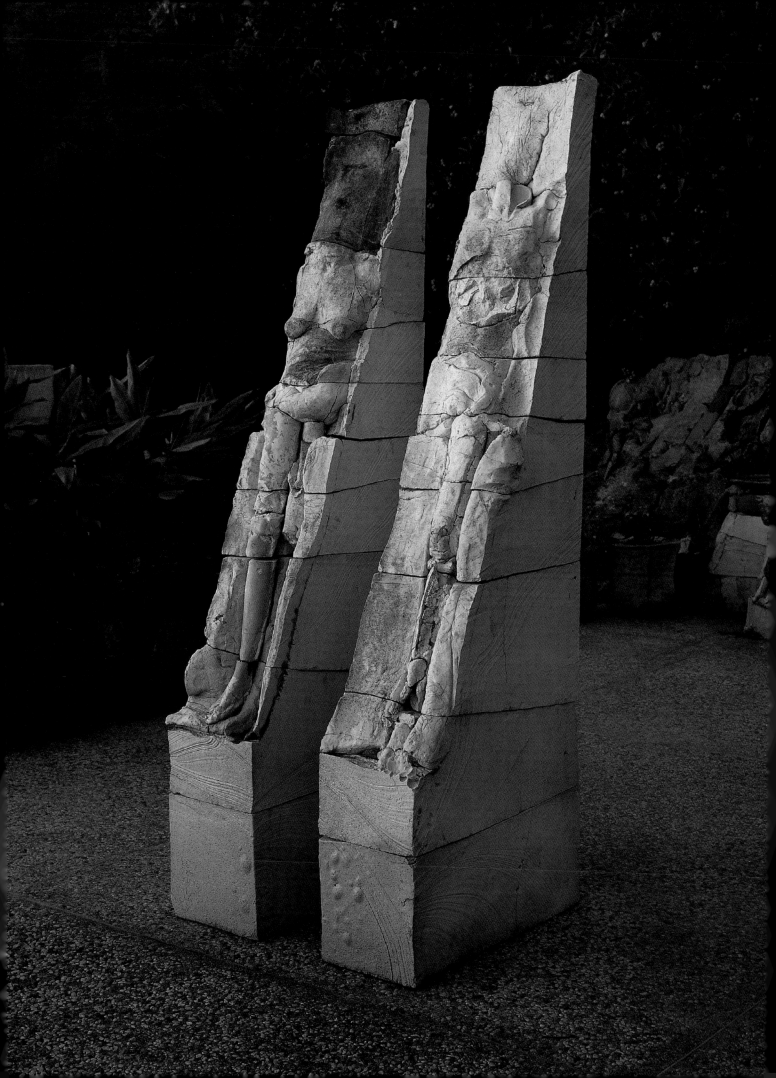

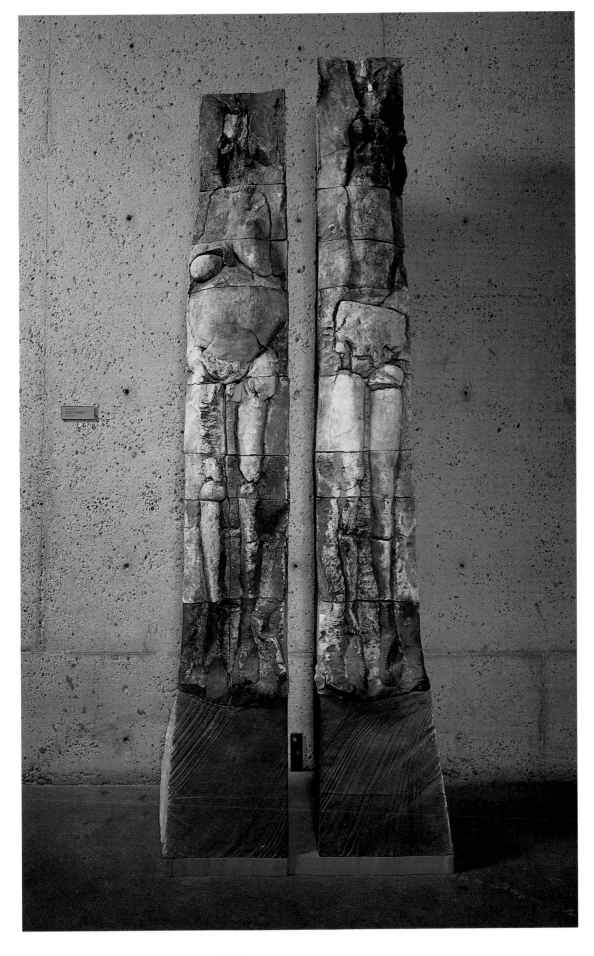

55. *Pregnant Woman*, 1978 (left), and *Standing Man*, 1978 (right)

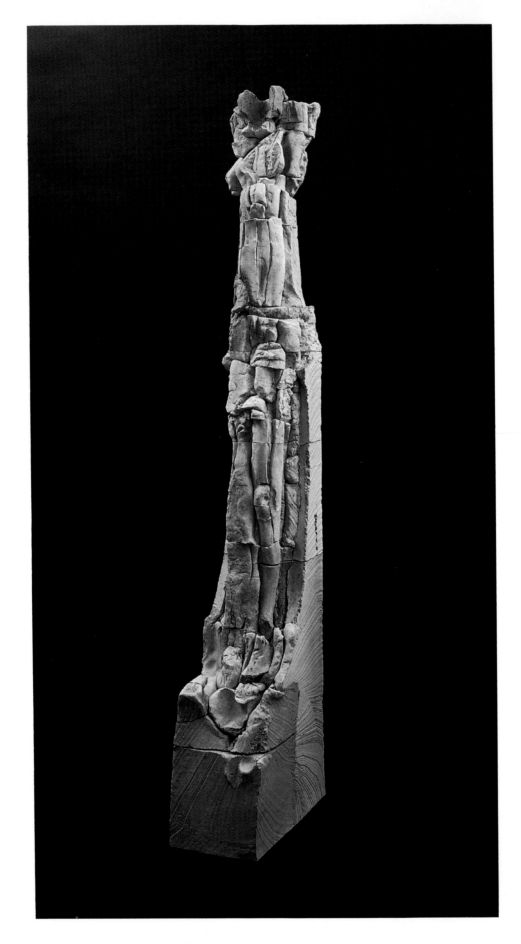

56. *Standing Figure with Segmented Knee*, 1979

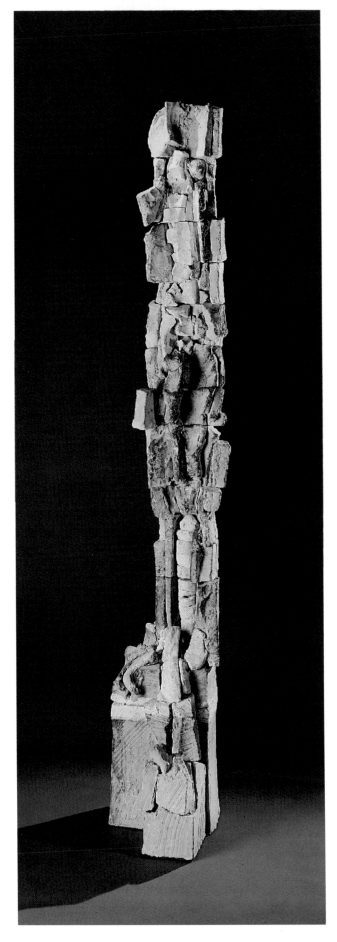

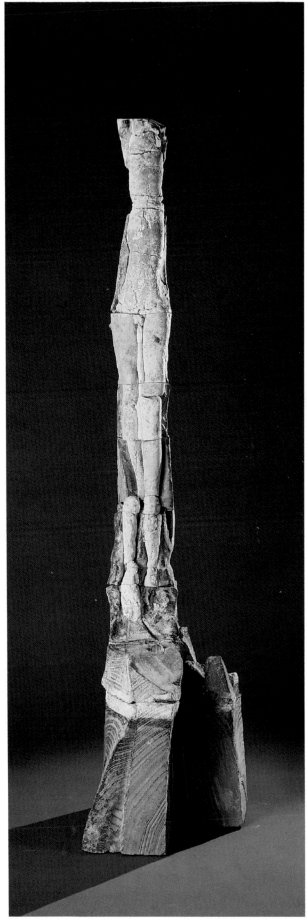

57. *Standing Figure with Striped Leg,* 1979

58. *Standing Woman with Flared Base,* 1979

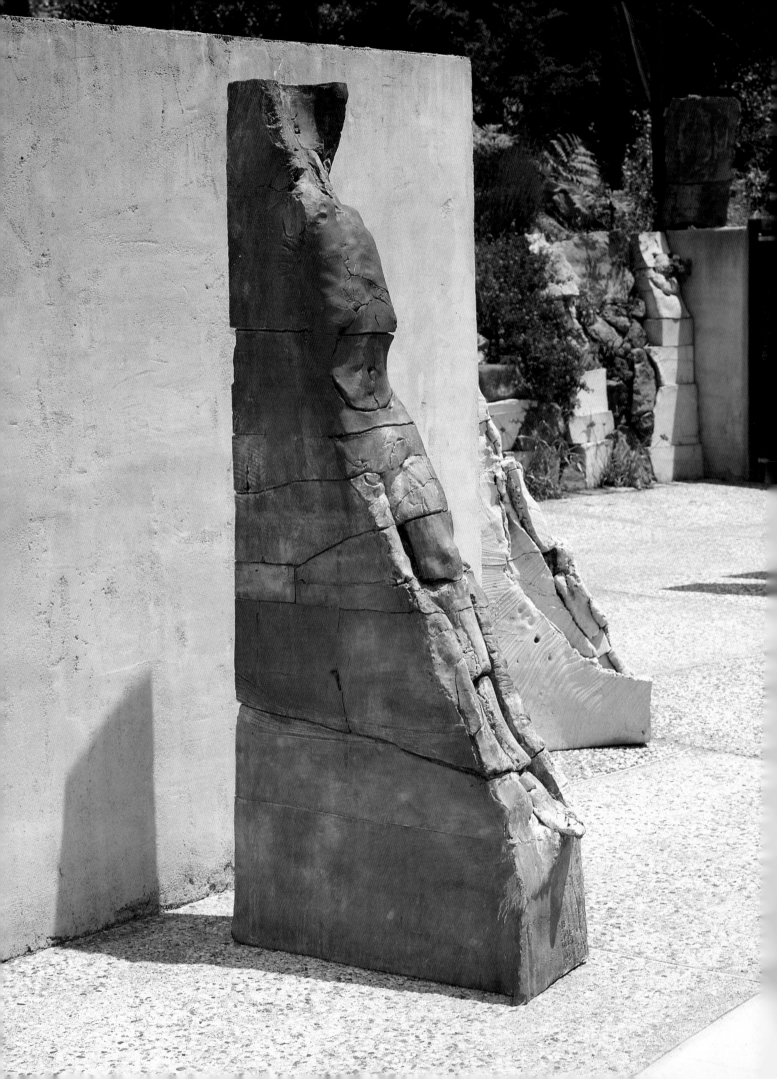

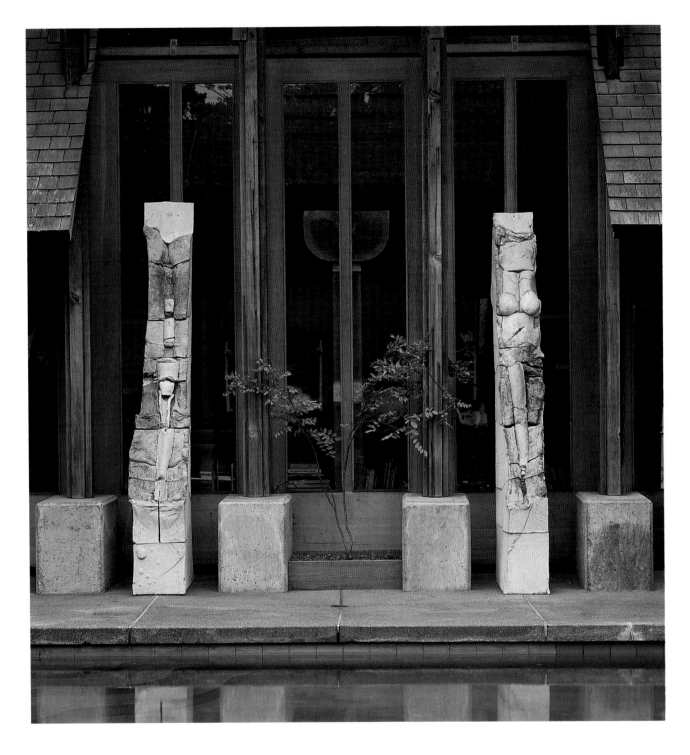

59. *Wedged Man Standing III*, 1982

60. *Standing Man Blue*, 1975 (left), and *Standing Woman Pale Blue*, 1975 (right)

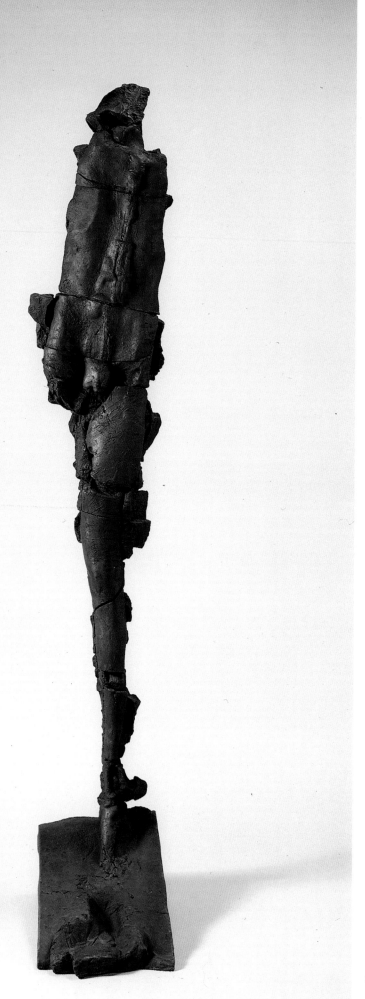

61. *Man on One Leg*, 1982

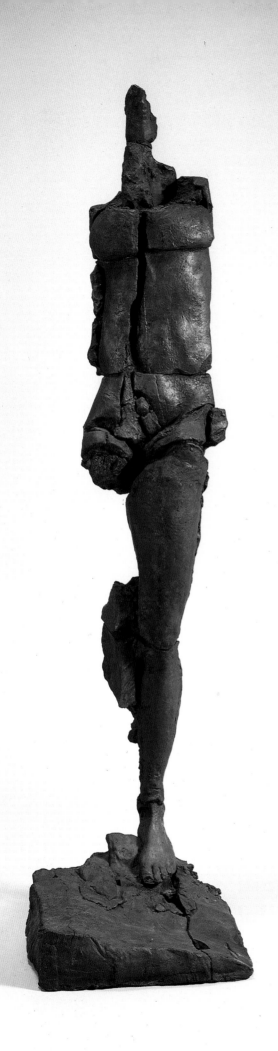

62. *Bisected Woman Standing*, 1982

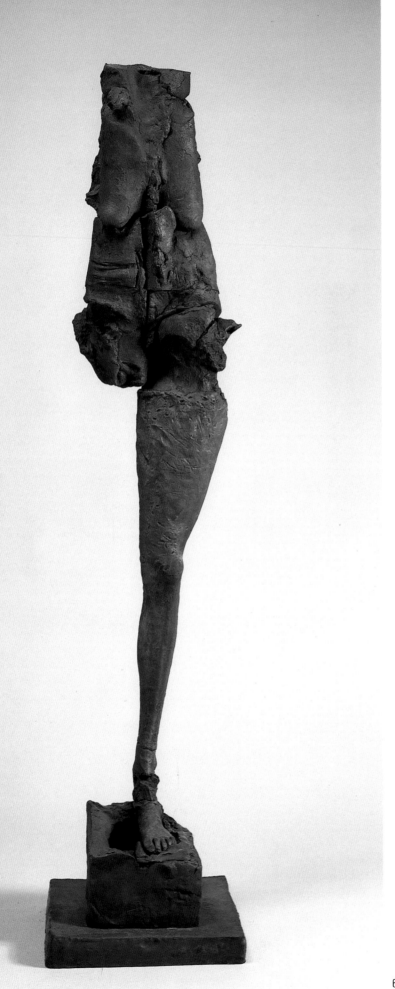

63. *One-Legged Woman Standing*, 1982

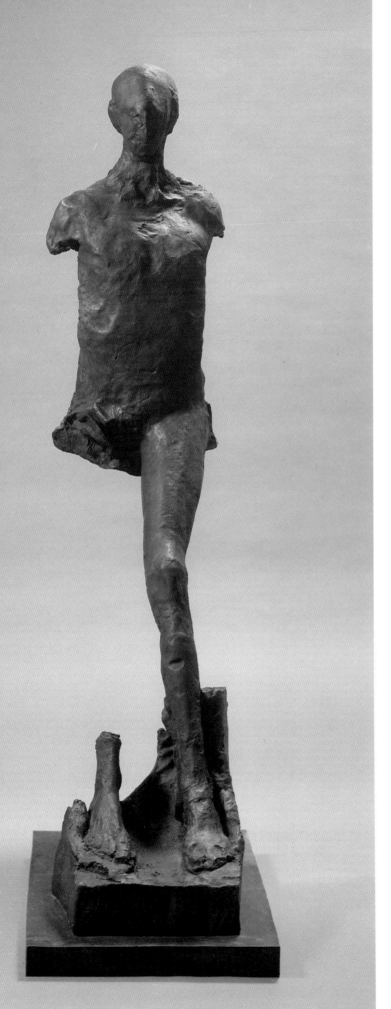

64. *Seated Man with One Leg*, 1983

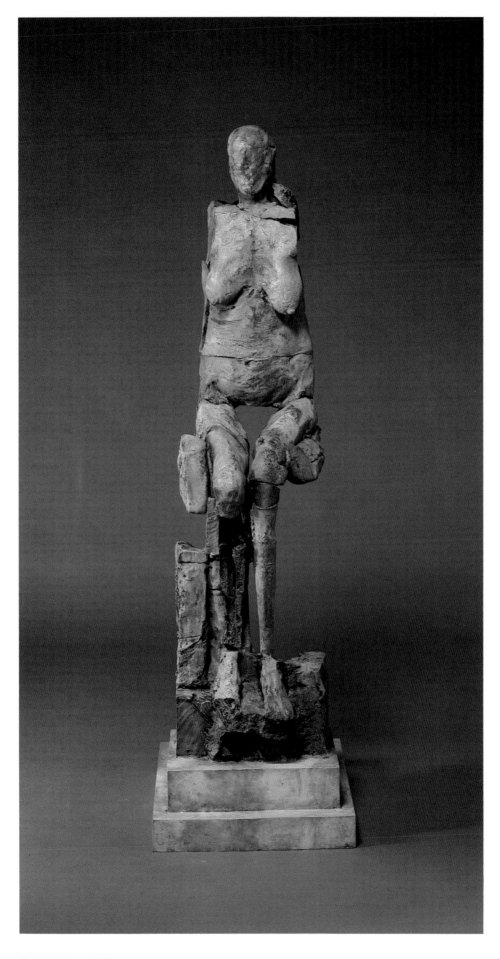

65. *Sitting Woman*, 1987

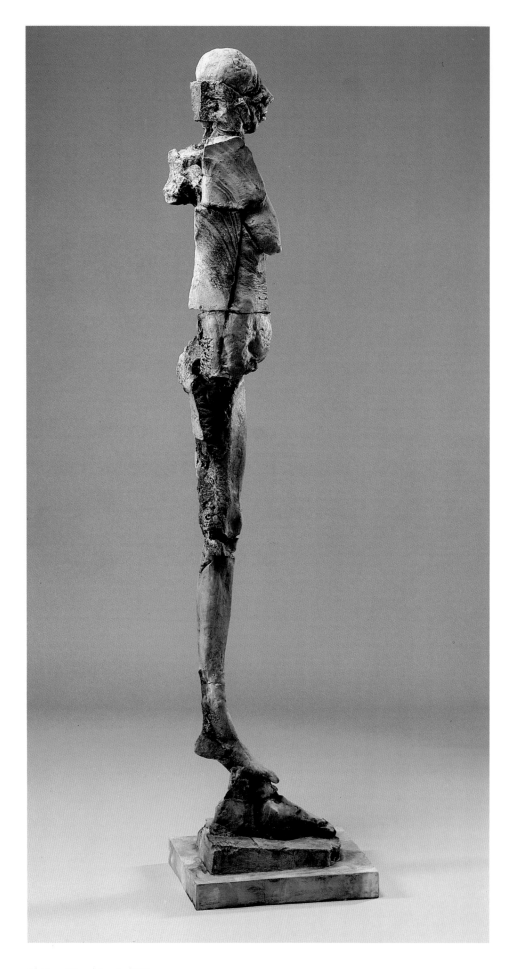

66. *Seated Woman Standing*, 1987

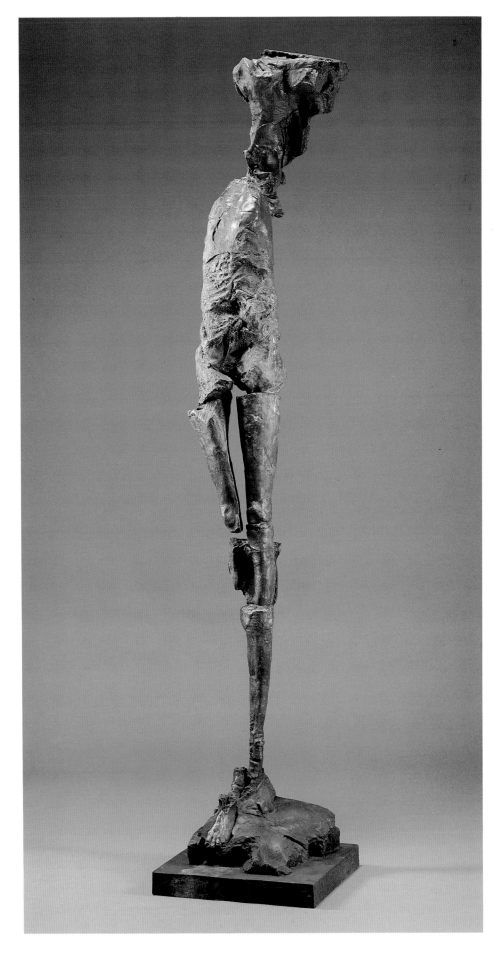

67. *Clubwinged Angel*, 1987

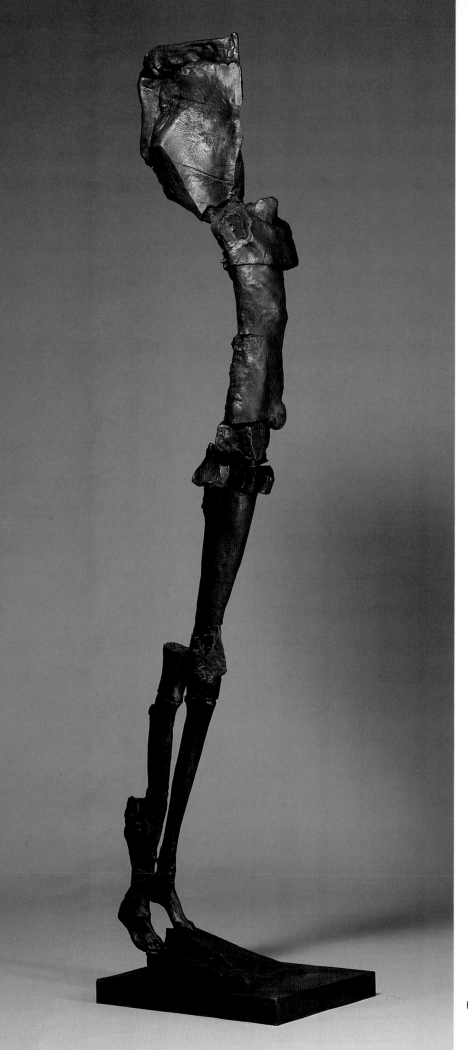

68. *Wedge-Winged Man with Hollow Heart,* 1987

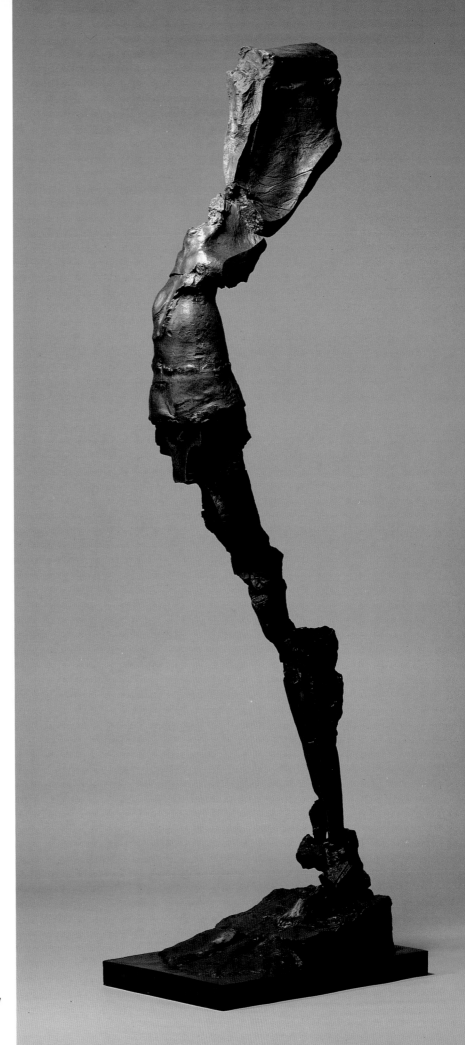

69. *Archangel*, 1987

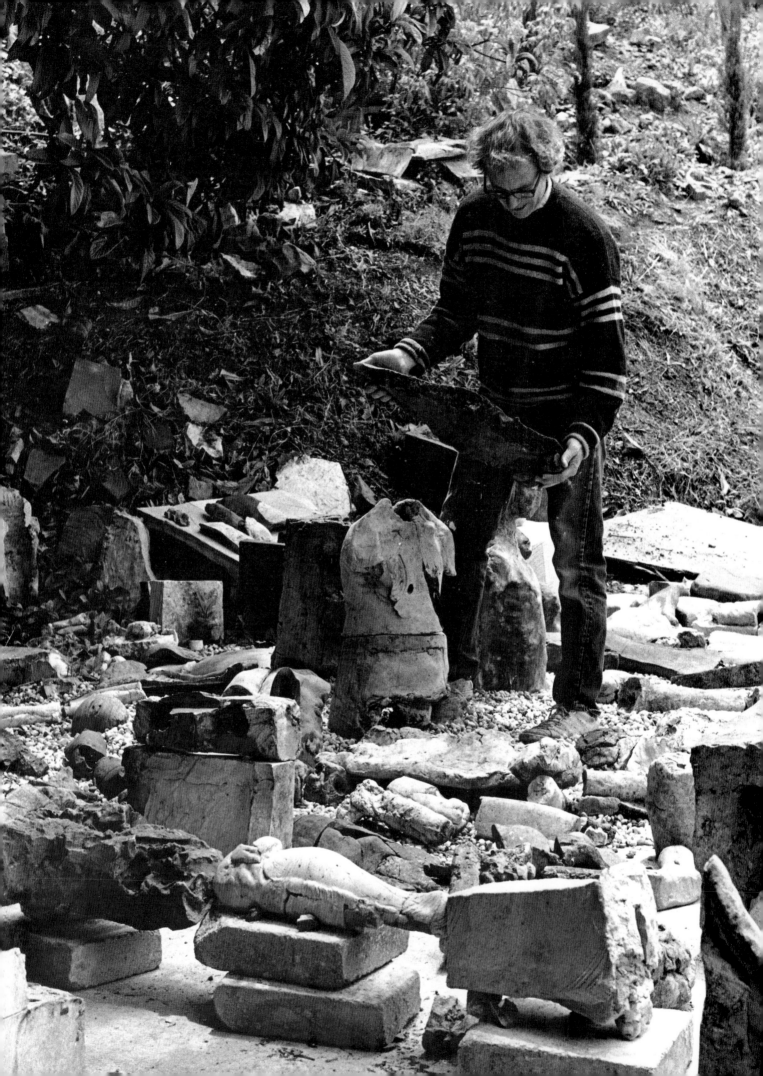

LIST OF COLOR PLATES

All works in clay are colored both with ceramic pigments, which are integral to the clay, and with surface stains. All works in bronze are cast and colored with chemical patinas. In addition, some works are poly-chromed with acrylic and/or oil pigments.

In the listing of the dimensions, height precedes width precedes depth. Works included in the traveling exhibition are followed by an asterisk (*). Please note that *Compressed Stele Rising*, *Phoenix Stele*, and *Standing Woman with Twisting Torso* (no. 6) will not be exhibited in Laguna Beach. *Right-Sided Woman Standing* (no. 34) will be shown only in San Francisco, Purchase, and Washington, D.C., and *Standing Man Blue* and *Standing Woman Pale Blue* (no. 60) will be exhibited in San Francisco only.

Solo exhibitions and group exhibitions documented by a catalogue are listed after each work. For additional information on these exhibitions, see Exhibition History.

1. *Seated Woman with Outstretched Hand*, 1984*
 porcelain, stoneware, and low-fire clays
 77 × 17 × 28″ (195.6 × 43.2 × 71.1 cm)
 Courtesy of John Berggruen Gallery, San Francisco
 Exhibited:
 1987 Philbrook Museum of Art, Tulsa, Oklahoma
 1986 John Berggruen Gallery, San Francisco

2. *Standing Figure with Dark Aura*, 1984
 porcelain, stoneware, and low-fire clays
 99 × 18 × 21″ (251.5 × 45.7 × 53.3 cm)
 Courtesy of CDS Gallery, New York
 Exhibited:
 1987 Everson Museum of Art, Syracuse,
 New York
 1985 CDS Gallery, New York
 Robert Kidd Gallery, Birmingham,
 Michigan

3. *Standing Figure with Flattened Torso*, 1984
 porcelain, stoneware, and low-fire clays
 84½ × 14 × 18″ (214.6 × 35.6 × 45.7 cm)
 Collection of Pedro Pérez Lazo, Caracas, Venezuela
 Exhibited:
 1985 CDS Gallery, New York

4. *Standing Figure with Segmented Torso*, 1985
 porcelain, stoneware, and low-fire clays
 95 × 14 × 23″ (241.3 × 35.6 × 58.4 cm)
 Courtesy of John Berggruen Gallery, San Francisco
 Exhibited:
 1986 John Berggruen Gallery, San Francisco

5. *Wedged Woman Standing*, 1985*
 porcelain, stoneware, and low-fire clays
 104 × 19 × 23″ (264.2 × 48.3 × 58.4 cm)
 Courtesy of John Berggruen Gallery, San Francisco
 Exhibited:
 1986 John Berggruen Gallery, San Francisco

6. *Compressed Stele Rising*, 1979 (left)*
 porcelain, stoneware, and low-fire clays
 109 × 12 × 24½″ (276.9 × 30.5 × 62.2 cm)
 Collection of Mr. and Mrs. Matthew Strauss,
 Rancho Santa Fe, California
 Exhibited:
 1982 Oakland Museum, California
 1981 American Craft Museum, New York
 1980 San Francisco Museum of Modern Art
 1979 James Willis Gallery, San Francisco

 Phoenix Stele, 1979 (center)*
 porcelain, stoneware, and low-fire clays
 106 × 13 × 25″ (269.2 × 33 × 63.5 cm)
 Collection of Mr. and Mrs. Matthew Strauss,
 Rancho Santa Fe, California
 Exhibited:
 1982 Maryland Institute, Baltimore
 Oakland Museum, California
 1980 San Francisco Museum of Modern Art
 1979 James Willis Gallery, San Francisco

 Standing Woman with Twisting Torso, 1979 (right)*
 porcelain and low-fire clays
 107 × 12½ × 23″ (271.8 × 31.8 × 58.4 cm)
 Collection of Mr. and Mrs. Matthew Strauss,
 Rancho Santa Fe, California
 Exhibited:
 1982 Oakland Museum, California
 1980 San Francisco Museum of Modern Art
 1979 James Willis Gallery, San Francisco

Artist with clay fragments in the early 1980s.

7. *Standing Figure with Tilting Head*, 1985 (left)
porcelain and low-fire clays
91½ × 15 × 21″ (232.4 × 38.1 × 53.3 cm)
Collection of Jane and Leonard Korman,
Fort Washington, Pennsylvania
Exhibited:
 1986 John Berggruen Gallery, San Francisco

Standing Figure with Yellow Aura, 1985 (right)*
porcelain, stoneware, and low-fire clays
92½ × 21 × 19″ (235 × 53.3 × 48.3 cm)
Collection of the Morgan Flagg Family,
Monterey, California
Exhibited:
 1985 CDS Gallery, New York

8. *Seated Figure with Striped Right Arm*, 1984 (left)
porcelain, stoneware, and low-fire clays
73 × 17 × 29″ (185 × 43.2 × 73.7 cm)
Courtesy of John Berggruen Gallery, San Francisco
Exhibited:
 1987 Philbrook Museum of Art, Tulsa, Oklahoma
 1986 John Berggruen Gallery, San Francisco

Seated Figure with Yellow Flame, 1985 (right)
porcelain, stoneware, and low-fire clays
78 × 14 × 29″ (198.1 × 35.6 × 73.7 cm)
Courtesy of John Berggruen Gallery, San Francisco
Exhibited:
 1987 Philbrook Art Center, Tulsa, Oklahoma
 1986 John Berggruen Gallery, San Francisco

9. *Left-Sided Angel*, 1986
bronze, unique cast
101 × 24 × 35″ (256.5 × 61 × 88.9 cm)
Collection of Iowa State University, Ames
Exhibited:
 1986 Permanent installation at Iowa State
 University, Ames

10. *Seated Man Bisected*, 1981*
bronze, artist's proof, edition of 4
71½ × 23 × 26″ (181.6 × 58.4 × 66 cm)
Courtesy of CDS Gallery, New York
Exhibited:
 1985 Sheldon Memorial Art Gallery, University
 of Nebraska, Lincoln
 1984 CDS Gallery, New York
 1982 Fuller Goldeen Gallery, San Francisco
 Tortue Gallery, Santa Monica, California

11. *Seated Woman Bisected*, 1981*
bronze, artist's proof, edition of 4
70 × 23 × 24″ (177.8 × 58.4 × 61 cm)
Courtesy of CDS Gallery, New York
Exhibited:
 1985 Sheldon Memorial Art Gallery, University
 of Nebraska, Lincoln
 1984 CDS Gallery, New York
 1982 Fuller Goldeen Gallery, San Francisco
 Tortue Gallery, Santa Monica, California

12. *Left-Sided Figure Pointing*, 1983*
bronze, unique cast
81½ × 30 × 38″ (207 × 76.2 × 96.5 cm)
Courtesy of CDS Gallery, New York
Exhibited:
 1984 CDS Gallery, New York

13. *Winged Woman*, 1986
bronze, unique cast
89½ × 15½ × 19½″ (227.3 × 39.4 × 49.5 cm)
Courtesy of CDS Gallery, New York
Exhibited:
 1986 CDS Gallery, New York

14. *Man with Flame*, 1985
bronze, unique cast
78¼ × 18 × 13½″ (198.8 × 45.7 × 34.3 cm)
Collection of the City and County of San Francisco
Exhibited:
 1986 John Berggruen Gallery, San Francisco
 Permanent installation at the Moscone
 Center, San Francisco

15. *Pregnant Woman*, 1982*
bronze, artist's proof, edition of 4
78 × 26½ × 26¼″ (198.1 × 67.3 × 66.7 cm)
Courtesy of CDS Gallery, New York
Exhibited:
 1987 Palm Springs Desert Museum, California
 1984 CDS Gallery, New York

16. *Leg VIII*, 1981
bronze, artist's proof, edition of 4
44 × 12 × 16½″ (111.8 × 30.5 × 41.9 cm)
Collection of Rene di Rosa, Napa, California
Exhibited:
 1982 John Berggruen Gallery, San Francisco

17. *Lavender Leg with Double Foot*, 1979
porcelain and low-fire clays
54½ × 11 × 9″ (138.4 × 27.9 × 22.9 cm)
Collection of Mr. and Mrs. Carter Thacher,
San Francisco
Exhibited:
 1979 James Willis Gallery, San Francisco

18. *Right-Sided Angel*, 1986*
bronze, artist's proof, edition of 4
108 × 26 × 22″ (274.3 × 66 × 55.9 cm)
Collection of Mr. and Mrs. Emilio Azcarraga,
Los Angeles
Exhibited:
 1986 CDS Gallery, New York

19. *Pregnant Woman II*, 1986
bronze, unique cast
84 × 21 × 19½″ (213.4 × 53.3 × 49.5 cm)
Courtesy of CDS Gallery, New York
Exhibited:
 1986 CDS Gallery, New York

20. *Pregnant Woman IV*, 1986*
 bronze, unique cast
 71 × 17 × 22½″ (180.3 × 43.2 × 57.2 cm)
 Private collection, Coral Gables, Florida
 Exhibited:
 1986 CDS Gallery, New York

21. *Pressed-Breast Torso*, 1976
 porcelain and stoneware clays
 21 × 12 × 3½″ (53.3 × 30.5 × 8.9 cm)
 Private collection
 Exhibited:
 1979 Grossmont College, El Cajon, California
 1977 James Willis Gallery, San Francisco

22. *Wall Torso I*, 1983
 porcelain and stoneware clays
 30 × 10 × 5″ (76.2 × 25.4 × 12.7 cm)
 Courtesy of CDS Gallery, New York
 Exhibited:
 1986 CDS Gallery, New York
 1985 CDS Gallery, New York

23. *Man with Tar Heart*, 1981*
 bronze and tar, artist's proof, edition of 4
 26½ × 15½ × 9″ (67.3 × 39.4 × 22.9 cm)
 Collection of John Williams, San Francisco
 Exhibited:
 1982 Fuller Goldeen Gallery, San Francisco

24. *Lavender Torso with Mask*, 1976/1985*
 porcelain and low-fire clays, leather
 33 × 11½ × 9½″ (83.8 × 29.2 × 24.1 cm)
 Collection of Wellington Henderson, San Francisco
 Exhibited:
 1986 John Berggruen Gallery, San Francisco

25. *Face with Blue Eye*, 1982
 bronze, unique cast
 6¾ × 4¾ × 2½″ (17.1 × 12.1 × 6.4 cm)
 Courtesy of CDS Gallery, New York
 Exhibited:
 1986 CDS Gallery, New York

26. *Man with Melting Mouth*, 1966/1981
 bronze, unique cast
 9 × 5 × 4½″ (22.9 × 12.7 × 11.4 cm)
 Private collection
 Exhibited:
 1974 Oakland Museum, California

27. *Head with Mask*, 1972/1983
 bronze with porcelain head
 11 × 8½ × 7″ (27.9 × 21.6 × 17.8 cm)
 Private collection
 Exhibited:
 1986 John Berggruen Gallery, San Francisco

28. *Head with Bated Breath*, 1983
 bronze, artist's proof, edition of 4
 12 × 7½ × 7″ (30.5 × 19.1 × 17.8 cm)
 Collection of Rita and Toby Schreiber
 Exhibited:
 1985 Hillwood Art Gallery, Long Island
 University, Brookville, New York

29. *Wedged Man Standing II*, 1981
 bronze, artist's proof, edition of 4
 88½ × 17 × 25″ (224.8 × 43.2 × 63.5 cm)
 Courtesy of John Berggruen Gallery, San Francisco
 Exhibited:
 1982 John Berggruen Gallery, San Francisco

30. *Standing Figure with Quartered Torso*, 1985*
 porcelain, stoneware, and low-fire clays
 93 × 15 × 23″ (236.2 × 38.1 × 58.4 cm)
 Courtesy of John Berggruen Gallery, San Francisco
 Exhibited:
 1986 John Berggruen Gallery, San Francisco

31. *Lavender Figure Column*, 1979 (left)*
 porcelain and low-fire clays
 78½ × 10 × 12″ (199.4 × 25.4 × 30.5 cm)
 Collection of Ernie and Lynn Mieger, San Francisco
 Exhibited:
 1979 James Willis Gallery, San Francisco

 Lavender Figure Column with Yellow, 1979 (right)*
 porcelain and low-fire clays
 77 × 9 × 11″ (195.6 × 22.9 × 27.9 cm)
 Collection of William Matson Roth, San Francisco
 Exhibited:
 1979 James Willis Gallery, San Francisco

32. *Seated Figure Pale Blue*, 1984 (left)
 porcelain and low-fire clays
 79½ × 14 × 25″ (202 × 35.6 × 63.5 cm)
 Courtesy of CDS Gallery, New York
 Exhibited:
 1985 CDS Gallery, New York

 Seated Figure with Cleft, 1984 (right)
 porcelain, stoneware, and low-fire clays
 83 × 15 × 24″ (210.8 × 38.1 × 61 cm)
 Courtesy of CDS Gallery, New York
 Exhibited:
 1987 American Craft Museum, New York
 1985 CDS Gallery, New York

33. *Standing Figure with Bow Leg*, 1979 (left)*
 porcelain and low-fire clays
 86½ × 11½ × 26″ (219.7 × 29.2 × 66 cm)
 Private collection
 Exhibited:
 1980 San Francisco Museum of Modern Art
 1979 James Willis Gallery, San Francisco

 Standing Woman with Yellow Breast, 1979 (right)*
 porcelain and low-fire clays
 87½ × 14½ × 26½″ (222.3 × 36.8 × 67.3 cm)
 Collection of Rene di Rosa, Napa, California
 Exhibited:
 1980 San Francisco Museum of Modern Art
 1979 James Willis Gallery, San Francisco

34. *Right-Sided Woman Standing*, 1979*
 porcelain and low-fire clays
 90½ × 12 × 12″ (229.9 × 30.5 × 30.5 cm)
 Collection of Byron Meyer, San Francisco
 Exhibited:
 1979 James Willis Gallery, San Francisco

35. *Fallen Figure Standing*, 1979*
 porcelain and low-fire clays
 84½ × 9½ × 11″ (214.6 × 24.1 × 27.9 cm)
 Collection of Mr. and Mrs. Peter Blumberg,
 Portola Valley, California
 Exhibited:
 1979 James Willis Gallery, San Francisco

36. *Standing Man with One Pink Foot*, 1978
 porcelain and stoneware clays
 72 × 12 × 30″ (182.9 × 30.5 × 76.2 cm)
 Courtesy of John Berggruen Gallery, San Francisco
 Exhibited:
 1982 MKO Gallery, Japan
 San Jose Museum of Art, California
 1981 Hansen Fuller Goldeen Gallery,
 San Francisco

37. *Standing Figure with Swayback*, 1978
 stoneware clay
 71½ × 14 × 15″ (181.6 × 35.6 × 38.1 cm)
 Private collection
 Exhibited:
 1982 MKO Gallery, Japan
 1981 Fuller Goldeen Gallery, San Francisco

38. *Laid-Back Figure Column*, 1979
 porcelain, stoneware, and low-fire clays
 92½ × 14 × 17″ (235 × 35.6 × 43.2 cm)
 Collection of Edna S. Beron

39. *Standing Figure with Ribs*, 1978 (left)
 porcelain, stoneware, and low-fire clays
 79 × 17 × 28″ (200.7 × 43.2 × 71.1 cm)
 Courtesy of CDS Gallery, New York
 Exhibited:
 1987 Palm Springs Desert Museum, California
 1985 CDS Gallery, New York
 1984 Museum of Fine Arts, Boston
 1982 Maryland Institute, College of Art,
 Baltimore
 1981 Hansen Fuller Goldeen Gallery,
 San Francisco

 Standing Woman with Missing Hip, 1978 (right)
 porcelain, stoneware, and low-fire clays
 81 × 18 × 30″ (205.7 × 45.7 × 76.2 cm)
 Courtesy of CDS Gallery, New York
 Exhibited:
 1987 Palm Springs Desert Museum, California
 1985 CDS Gallery, New York
 1984 Museum of Fine Arts, Boston
 1982 Maryland Institute, College of Art,
 Baltimore
 1981 Hansen Fuller Goldeen Gallery,
 San Francisco

40. *Man with Lip-Eye*, 1981*
 bronze, unique cast
 26½ × 15½ × 9″ (67.3 × 39.4 × 22.9 cm)
 Collection of Robert Hutchinson, San Francisco
 Exhibited:
 1982 Fuller Goldeen Gallery, San Francisco

41. *Blue Torso Column*, 1984*
 bronze, artist's proof, edition of 4
 48 × 10 × 9″ (121.9 × 25.4 × 22.9 cm)
 Collection of Dr. W. Jost Michelsen, New York
 Exhibited:
 1986 CDS Gallery, New York

42. *Yellow Eye/Blue Eye*, 1973
 porcelain
 7 × 4½ × 3″ (17.8 × 11.4 × 7.6 cm)
 Private collection
 Exhibited:
 1974 Oakland Museum, California

43. *Lavender Face with Missing Eye*, 1976
 porcelain
 6½ × 4 × 2″ (16.5 × 10.2 × 5.1 cm)
 Private collection
 Exhibited:
 1977 James Willis Gallery, San Francisco

44. *Standing Figure with Blue Shoulder*, 1983
 bronze, 2/3
 75½ × 15 × 17½″ (191.8 × 38.1 × 44.5 cm)
 Collection of Mr. and Mrs. David Guss, La Jolla,
 California

45. *Seated Woman with Left Leg*, 1985
 stoneware clay
 62½ × 18 × 27″ (158.8 × 45.7 × 68.6 cm)
 Courtesy of CDS Gallery, New York

46. *Right-Sided Woman Sitting*, 1985
 stoneware clay
 63½ × 21 × 25″ (161.3 × 53.3 × 63.5 cm)
 Courtesy of CDS Gallery, New York
 Exhibited:
 1985 CDS Gallery, New York

47. *Standing Man with Stone*, 1986
 bronze, unique cast
 83¼ × 20½ × 28″ (211.5 × 52.1 × 71.1 cm)
 Private collection, Miami Beach, Florida
 Exhibited:
 1986 CDS Gallery, New York

48. *Female Torso*, 1981
 bronze, artist's proof, edition of 4
 17¼ × 15½ × 16″ (43.8 × 39.4 × 40.6 cm)
 Courtesy of CDS Gallery, New York
 Exhibited:
 1986 CDS Gallery, New York

49. *Seated Man with Winged Head*, 1981*
bronze, artist's proof, edition of 4
67½ × 23 × 26″ (171.5 × 58.4 × 66 cm)
On extended loan to the Laumeier International
Sculpture Park, St. Louis, Missouri
Exhibited:
 1983 The Charles H. Scott Gallery, Emily Carr
 College of Art, Granville Island,
 Vancouver, British Columbia, and
 The Art Museum Association of
 America, San Francisco
 1982 Fuller Goldeen Gallery, San Francisco

50. *Seated Woman with Oval Head*, 1981*
bronze, artist's proof, edition of 4
68 × 23 × 25½″ (172.7 × 58.4 × 64.8 cm)
On extended loan to the Laumeier International
Sculpture Park, St. Louis, Missouri
Exhibited:
 1983 The Charles H. Scott Gallery, Emily Carr
 College of Art, Granville Island,
 Vancouver, British Columbia, and
 The Art Museum Association of
 America, San Francisco
 1982 Fuller Goldeen Gallery, San Francisco

51. *Left-Sided Figure Standing*, 1981
bronze, 1/4
76 × 9 × 9″ (193 × 22.9 × 22.9 cm)
Courtesy of John Berggruen Gallery, San Francisco
Exhibited:
 1983 The Charles H. Scott Gallery, Emily Carr
 College of Art, Granville Island,
 Vancouver, British Columbia, and
 The Art Museum Association of
 America, San Francisco
 1982 John Berggruen Gallery, San Francisco

52. *Double Torso on One Leg*, 1985
porcelain and low-fire clays
89 × 17 × 18″ (226.1 × 43.2 × 45.7 cm)
The Shidler Collection, Honolulu, Hawaii
Exhibited:
 1986 John Berggruen Gallery, San Francisco

53. *Cleft Stele*, 1979
porcelain, stoneware, and low-fire clays
88 × 11 × 12″ (223.5 × 27.9 × 30.5 cm)
Collection of Hope and Mel Barkan, Weston,
Massachusetts

54. *Standing Woman*, 1975 (left)*
porcelain, stoneware, and low-fire clays
96 × 14 × 33½″ (243.8 × 35.6 × 85.1 cm)
Private collection
Exhibited:
 1979 Everson Museum of Art, Syracuse,
 New York
 1978 Everson Museum of Art, Syracuse,
 New York
 1977 Indianapolis Museum of Art, Indiana
 James Willis Gallery, San Francisco

Standing Man, 1975 (right)*
porcelain and low-fire clays
96 × 14½ × 33½″ (243.8 × 36.8 × 85.1 cm)
Private collection
Exhibited:
 1979 Everson Museum of Art, Syracuse,
 New York
 1978 Everson Museum of Art, Syracuse,
 New York
 1977 Indianapolis Museum of Art, Indiana
 James Willis Gallery, San Francisco

55. *Pregnant Woman*, 1978 (left)
porcelain, stoneware, and low-fire clays
80 × 16⅛ × 12½″ (203.2 × 41 × 31.8 cm)
Collection of The Minneapolis Institute of Arts
Exhibited:
 1979 Pennsylvania Academy of the Fine Arts,
 Philadelphia

Standing Man, 1978 (right)
porcelain, stoneware, and low-fire clays
92¾ × 16¼ × 12⅞″ (235.6 × 41.3 × 32.7 cm)
Collection of The Minneapolis Institute of Arts
Exhibited:
 1979 Pennsylvania Academy of Fine Arts,
 Philadelphia

56. *Standing Figure with Segmented Knee*, 1979
porcelain, stoneware, and low-fire clays
93 × 14 × 22″ (236.2 × 35.6 × 55.9 cm)
Courtesy of CDS Gallery, New York
Exhibited:
 1985 Clay Studio, Philadelphia
 1981 American Craft Museum, New York
 1979 James Willis Gallery, San Francisco

57. *Standing Figure with Striped Leg*, 1979
porcelain, stoneware, and low-fire clays
101 × 14 × 18″ (256.5 × 35.6 × 45.7 cm)
Collection of Martin Z. Margulies, Coconut Grove,
Florida
Exhibited:
 1986 Martin Z. Margulies Collection, Coconut
 Grove, Florida

58. *Standing Woman with Flared Base*, 1979
porcelain, stoneware, and low-fire clays
87 × 17 × 19″ (221 × 43.2 × 48.3 cm)
Private collection, St. Louis, Missouri

59. *Wedged Man Standing III*, 1982
bronze, artist's proof
71 × 12 × 29″ (180.3 × 30.5 × 73.7 cm)
Courtesy of John Berggruen Gallery, San Francisco

60. *Standing Man Blue*, 1975 (left)*
porcelain, stoneware, and low-fire clays
100 × 15½ × 34″ (254 × 39.4 × 86.4 cm)
Collection of Mr. and Mrs. Edmund W. Nash,
Belvedere, California; promised gift to the
San Francisco Museum of Modern Art
Exhibited:
 1977 James Willis Gallery, San Francisco

Standing Woman Pale Blue, 1975 (right)*
porcelain, stoneware, and low-fire clays
96½ × 12 × 33½″ (245.1 × 30.5 × 85.1 cm)
Collection of Mr. and Mrs. Edmund W. Nash,
Belvedere, California; promised gift to the
San Francisco Museum of Modern Art
Exhibited:
 1977 James Willis Gallery, San Francisco

61. *Man on One Leg*, 1982
bronze, unique cast
71½ × 13 × 21″ (181.6 × 33 × 53.3 cm)
Courtesy of CDS Gallery, New York
Exhibited:
 1984 CDS Gallery, New York

62. *Bisected Woman Standing*, 1982
bronze, unique cast
68¼ × 17½ × 20″ (173.4 × 44.5 × 50.8 cm)
Courtesy of CDS Gallery, New York
Exhibited:
 1984 CDS Gallery, New York

63. *One-Legged Woman Standing*, 1982
bronze, unique cast
69½ × 15½ × 15½″ (176.5 × 39.4 × 39.4 cm)
Courtesy of John Berggruen Gallery, San Francisco
Exhibited:
 1986 John Berggruen Gallery, San Francisco
 1984 University Art Museum, California State
 University, Long Beach

64. *Seated Man with One Leg*, 1983
bronze, unique cast
63 × 18 × 37½″ (160 × 45.7 × 95.3 cm)
Collection of the Neuberger Museum, State
University of New York at Purchase, gift of
Mr. and Mrs. David Guss
Exhibited:
 1984 CDS Gallery, New York

65. *Sitting Woman*, 1987
bronze, unique cast
67 × 20 × 24″ (170 × 50.8 × 61 cm)
Courtesy of CDS Gallery, New York

66. *Seated Woman Standing*, 1987
bronze, unique cast
77 × 15¼ × 20″ (195.6 × 38.7 × 50.8 cm)
Courtesy of CDS Gallery, New York
Exhibited:
 1987 CDS Gallery, New York

67. *Clubwinged Angel*, 1987*
bronze, unique cast
105 × 22 × 21″ (266.7 × 55.9 × 53.3 cm)
Courtesy of CDS Gallery, New York

68. *Wedge-Winged Man with Hollow Heart*, 1987*
bronze, unique cast
108½ × 20 × 30″ (275.6 × 50.8 × 76.2 cm)
Courtesy of CDS Gallery, New York
Exhibited:
 1987 CDS Gallery, New York

69. *Archangel*, 1987*
bronze, unique cast
119 × 26½ × 34½″ (302.3 × 67.3 × 87.6 cm)
Courtesy of CDS Gallery, New York

Artist assembling sculpture at Artworks Foundry, Berkeley, 1987.

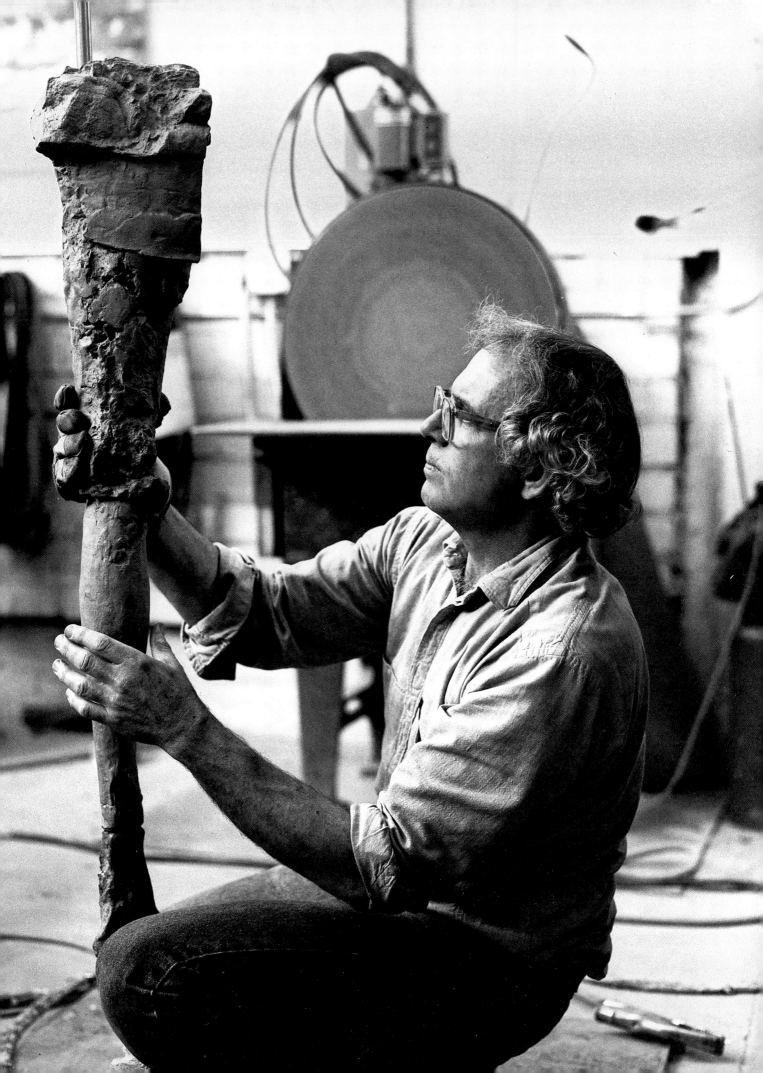

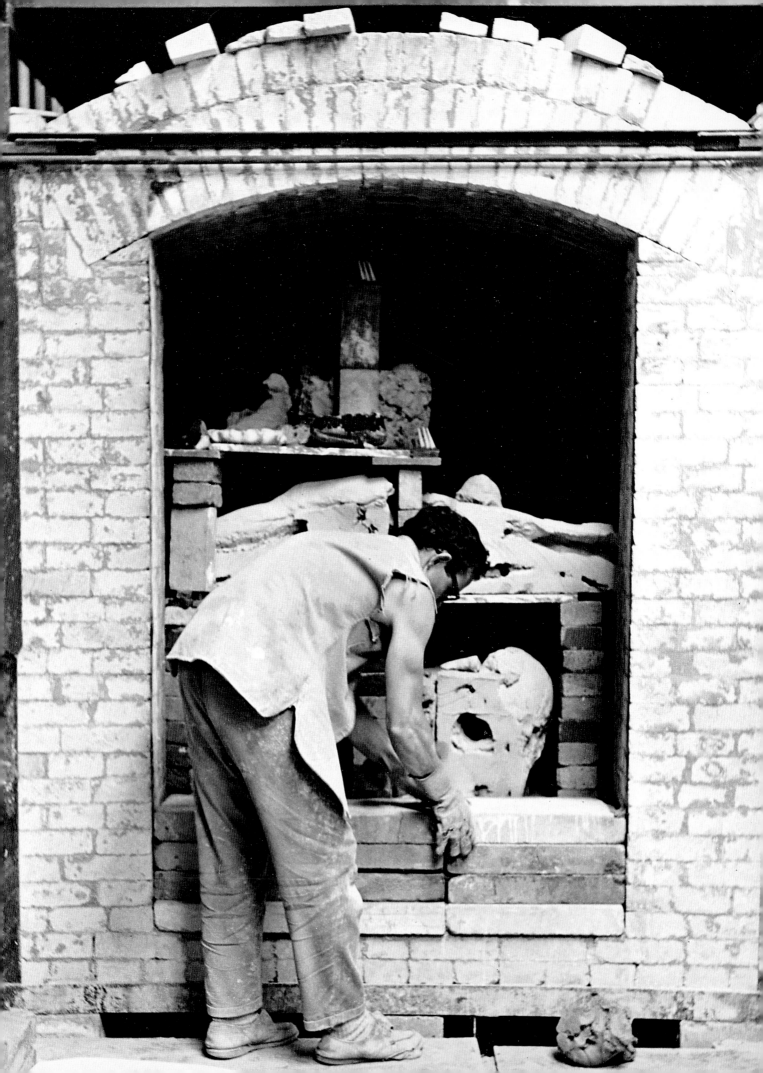

BIOGRAPHY

Born in 1933 in Saint Louis, Missouri

EDUCATION

1950-54 Princeton University, New Jersey, A.B.

1958-61 University of California, Berkeley, M.A.

TEACHING

1961-62 San Francisco State College

1961-67 San Francisco Art Institute

1967- San Francisco State University

SELECTED AWARDS

1954 Fulbright Scholarship

1965 Zellerbach Memorial Prize in Sculpture

1979 National Endowment for the Arts, Artists Fellowship

1981 National Endowment for the Arts, Artists Fellowship

1983 Guggenheim Fellowship

PUBLIC COMMISSIONS

1961 Wall sculpture, bronze, Consumers Cooperative of Berkeley

1963 *Moab*, clay, Prudential Federal Savings and Loan Association, Salt Lake City

1967-68 Sanctuary of the Holy Spirit Chapel, clay and bronze, Newman Center, Berkeley

1969 *Farnsworth Memorial Sculpture*, clay and bronze, Oakland Museum

1969-70 Seating environment and fireplace, clay, City College of San Francisco

1970 Seating environment, University Art Museum, University of California, Berkeley

1972 Water sculpture, clay and concrete, Bay Area Rapid Transit District, Concord Station, Concord, California

1975 *Ostwald Memorial Sculpture*, clay, Berkeley Public Library

1976-77 *Wall Canyon*, clay, Bay Area Rapid Transit District, Embarcadero Station, San Francisco

1980-81 *Syracusa*, clay, New State Building, Department of General Services, San Jose, California

1981-82 *Canyon*, clay, Pacific Mutual Insurance Company, Pacific Mutual Plaza, Newport Beach, California

1985-86 *Man with Flame*, bronze, Moscone Center, San Francisco

1985-87 *Birthplace*, clay, General Services Administration for the Old Post Office, Saint Louis

1986 *Left-Sided Angel*, bronze, Iowa State University, Ames

1986 Twin figure columns, bronze, Transpacific Development Corporation, Costa Mesa, California

1986-87 Light sculpture and water sculpture, New Harmony Inn and Conference Center, New Harmony, Indiana

Artist loading kiln in Albany, California, studio, in the mid-1960s.

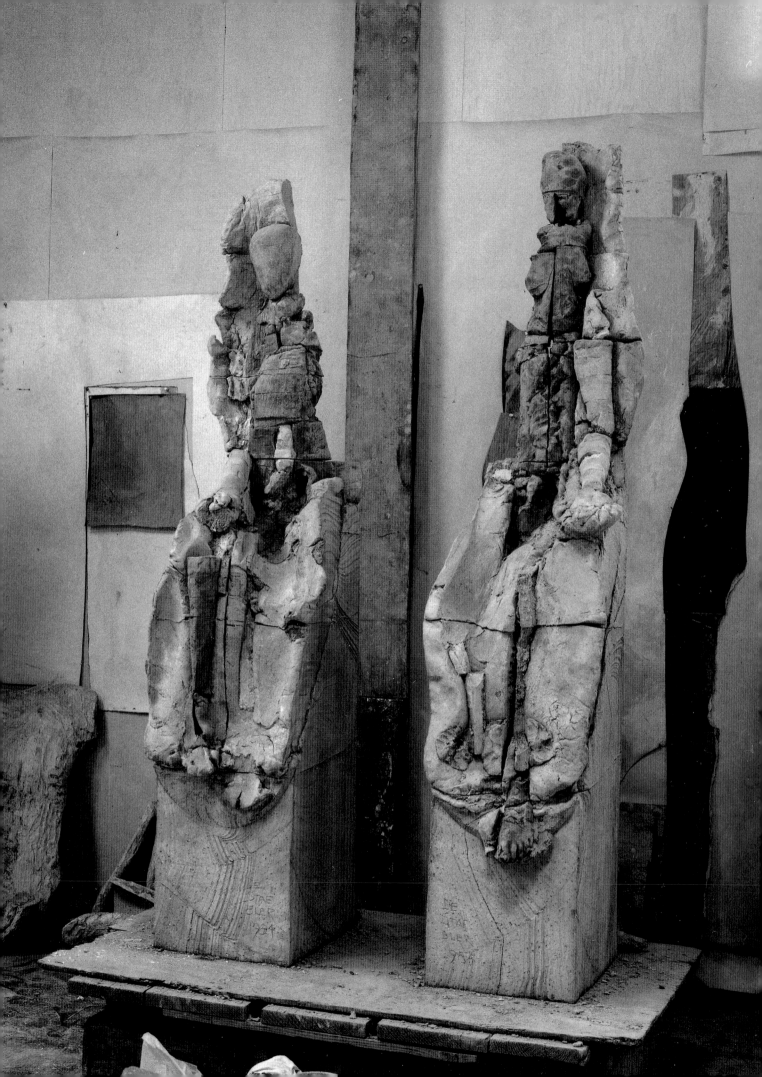

EXHIBITION HISTORY

Compiled by Karene Gould

ONE-MAN EXHIBITIONS

1987 CDS Gallery, New York, October 15 - November 14.

1986 CDS Gallery, New York, October 2 - November 1.

John Berggruen Gallery, San Francisco, January 15 - February 8.

1985 CDS Gallery, New York, October 3 - October 31.

1984 CDS Gallery, New York, October 24 - November 25.

1983 Charles H. Scott Gallery, Emily Carr College of Art, Vancouver, British Columbia, October 7 - November 15. Catalogue. Traveled to Scottsdale Center for the Arts, Arizona; Crocker Art Museum, Sacramento, California; Honolulu Academy of Arts, Hawaii; Laumeier International Sculpture Park, St. Louis; Virginia Polytechnic University, Blacksburg; Visual Arts Gallery, Florida International University, Miami; Art Museum of Santa Cruz County, California.

1982 Tortue Gallery, Santa Monica, California, September 10 - October 9.

John Berggruen Gallery, San Francisco, October 21 - November 20.

Fuller Goldeen Gallery, San Francisco, February 3 - February 27.

1981 Hansen Fuller Goldeen Gallery, San Francisco, February 3 - February 28.

Sheehan Gallery, Whitman College, Walla Walla, Washington.

1979 James Willis Gallery, San Francisco, November 15 - December 31.

Winona State University, Winona, Minnesota.

1978 James Willis Gallery, San Francisco, May 3 - June 17.

1977 James Willis Gallery, San Francisco, February 1 - February 28.

1974 Oakland Museum, California, September 10 - November 10. Catalogue.

GROUP EXHIBITIONS

1987 Everson Museum of Art, Syracuse, New York, *American Ceramics Now: Twenty-Seventh Ceramic National Exhibition*, April 8 - June 28. Catalogue. Traveled to American Craft Museum, New York; Crocker Art Museum, Sacramento, California; De Cordova and Dana Museum and Park, Lincoln, Massachusetts; Butler Institute of Art, Youngstown, Ohio; Sheldon Memorial Art Gallery, University of Nebraska, Lincoln; Birmingham Museum of Art, Alabama.

Joe and Emily Lowe Art Gallery, Syracuse University, New York, *Potters' Potters (Ceramic Artists: Work on Paper)*, April 8 - September 6.

Open-air Museum for Sculpture, Antwerp, Belgium, *Monumeta, 19th Biennale*, June 28 - November 10.

Palm Springs Desert Museum, California, *California Figurative Sculpture*, January 30 - March 15. Catalogue.

Berkeley studio, works in progress, 1984.

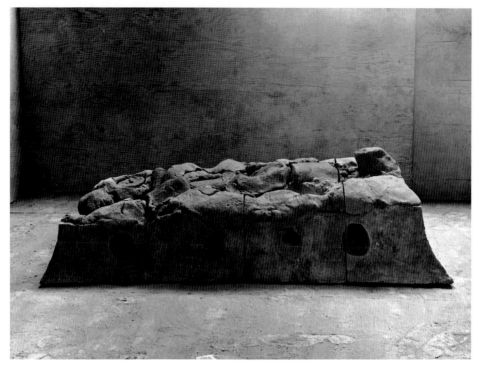

A Man, 1964, clay, 20 x 39 x 71".

Philbrook Museum of Art, Tulsa, Oklahoma, *The Eloquent Object*,
September 20, 1987– January 3, 1988. Catalogue. Traveled to Oakland
Museum, California; Museum of Fine Arts, Boston; The Chicago Public
Library Cultural Center; The Orlando Museum of Art, Florida; Virginia
Museum of Fine Arts, Richmond.

San Jose Institute of Contemporary Art, California, *Cast Metal '87*,
May 12– June 13.

1986 American Craft Museum, New York, *Craft Today: Poetry of the Physical*,
October 26, 1986– March 22, 1987. Catalogue. Traveled to The Denver Art
Museum; Laguna Art Museum, Laguna Beach, California; Phoenix Art
Museum; Milwaukee Art Museum; J. B. Speed Art Museum, Louisville,
Kentucky; Virginia Museum of Fine Arts, Richmond.

John Bergguen Gallery, San Francisco, *Sculpture and Works in Relief*,
October 9, 1986– January 10, 1987. Catalogue.

The Chicago Public Library Cultural Center, *Material and Metaphor:
Contemporary American Ceramic Sculpture*, February 1– March 29. Catalogue.

Civic Arts Gallery, Walnut Creek, California, *West Coast Clay*, June 5– August 3.

Civic Center Plaza, San Franciso, *Sculpture Exhibition: Arts Commission
Festival*, September 12– September 21.

Martin Z. Margulies Collection, Coconut Grove, Florida, *Contemporary Sculp-
ture from the Martin Z. Margulies Collection*, permanent installation. Catalogue.

Palo Alto Cultural Center, California, *A Survey of Slab Ceramics: From Object
to Expression*, May 18– June 29.

San Francisco State University Art Department Gallery, *The Guggenheim Show*,
October 13– October 18.

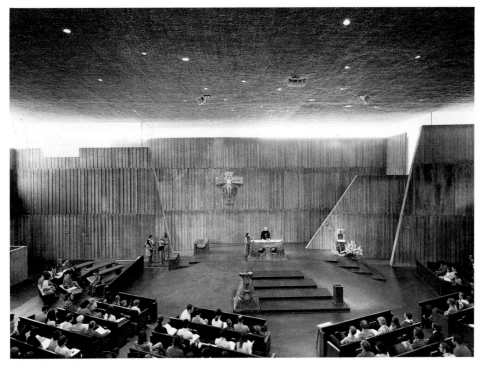

Sanctuary of the Newman Center, clay and bronze, 1967-68, Berkeley, California.

1985 Civic Arts Gallery, Walnut Creek, California, *Going Public — Sculpture from Studio to Site*, April 5 - May 19.

Dayton Art Institute, Ohio, *Clay*, March 19 - June 16. Catalogue.

Fine Arts Gallery, California State University, Los Angeles, *Artists' Forum: Selected Faculty Artists from the California State University*, October 28 - November 8. Catalogue. Traveled to California State University, Long Beach; California State University, Fresno.

Hillwood Art Gallery, Long Island University, C. W. Post Campus, Brookville, New York, *The Doll Show: Artists' Dolls and Figurines*, December 11, 1985 - January 29, 1986. Catalogue.

Robert Kidd Gallery, Birmingham, Michigan, *Major Concepts: Clay*, December 12, 1985 - January 24, 1986. Catalogue.

John Michael Kohler Arts Center, Sheboygan, Wisconsin, *Clay: Everyday Plus Sunday*, September 15 - December 30.

909 Third Avenue, New York, *Made in the U.S.A. — Works by 11 American Sculptors.*

Oakland Museum, California, *Art in the San Francisco Bay Area: 1945 - 1980*, June 15 - August 18. Catalogue.

Port of History Museum, Philadelphia, *American Clay Artists: Philadelphia '85*, April 27 - June 9. Catalogue.

Rathbone Gallery, Junior College of Albany, New York, *The Figure in Ceramics.*

San Francisco State University Art Department Gallery, *Art Faculty Exhibition*, March 4 - March 15.

Sheldon Memorial Art Gallery, University of Nebraska, Lincoln, *Contemporary Bronze: Six in the Figurative Tradition*, November 19, 1985 - January 19, 1986. Catalogue. Traveled to Kansas City Art Institute, Missouri; Des Moines Art Center, Iowa.

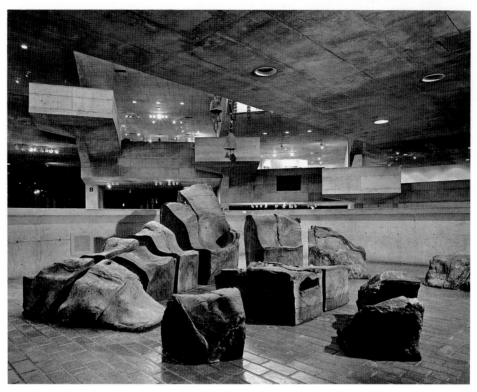

Seating environment done in 1970 for the University Art Museum, Berkeley.

University Center Gallery, Southern Illinois University, Edwardsville, *Surface Function Shape: Selections from the Earl Millard Collection*, March 24 - April 12. Catalogue.

Valparaiso University Art Gallery and Collections, Valparaiso, Indiana, *Arts Festival*, October 9 - November 17.

1984 California State University, Long Beach, *Figurative Sculpture: Ten Artists/Two Decades*, March 12 - April 19. Catalogue.

CDS Gallery, New York, *Artists Choose Artists III*, May 23 - June 30. Catalogue.

Helen Euphrat Gallery, De Anza College, Cupertino, California, *Faces*, February 7 - April 27. Catalogue.

Museum of Fine Arts, Boston, *Directions in Contemporary American Ceramics*, February 25 - June 3. Catalogue.

Penn Plaza, New York, *Seven Sculptors in America*, May 21 - September 21.

San Francisco Museum of Modern Art, *The 20th Century: The San Francisco Museum of Modern Art Collection*, December 9, 1984 - February 17, 1985.

University Art Gallery, Sonoma State University, Rohnert Park, California, *Works in Bronze — A Modern Survey*, November 2 - December 16. Catalogue. Traveled to Redding Museum and Art Center, California; University Art Gallery, Fresno State University, California; Palm Springs Desert Museum, California; Boise Gallery of Art, Idaho; Cheney Cowles Memorial Museum (Eastern Washington State Historical Society), Spokane, Washington; Sierra Nevada Museum of Art, Reno, Nevada; University Art Gallery, California State University, Turlock; University of California, Santa Cruz.

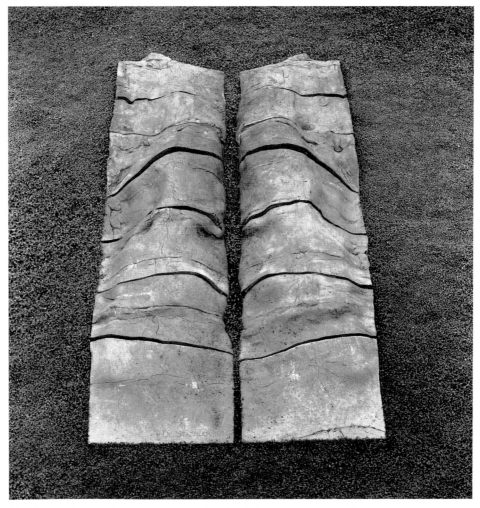

Moab II, 1972, clay, 14' l. Permanent installation at the Oakland Museum.

1983 Indiana University and Purdue University in cooperation with Artlink, Fort Wayne, Indiana, *Clayworks*, March 4 - March 26.

San Francisco Museum of Modern Art, *SFMMA Spring Auction 1983*, April 12. Catalogue.

1982 John Berggruen Gallery, San Francisco, *Aspects of Sculpture*, August 4 - September 11.

California Crafts Museum, Palo Alto, *Ceramics '82*, March 9 - April 18.

De Saisset Museum, Santa Clara, California, *Northern California Art of the Sixties*, October 12 - December 12. Catalogue.

Fresno Art Center, California, *Forgotten Dimension . . . A Survey of Small Sculpture in California Now*, April 4 - May 16. Catalogue. Traveled to San Francisco International Airport; Visual Arts Gallery, Illinois State University, Normal; Aspen Center for the Visual Arts, Colorado; Mary and Leigh Block Gallery, Northwestern University, Evanston, Illinois; Colorado Gallery of the Arts, Arapahoe Community College, Littleton; Palo Alto Cultural Center, California; Visual Arts Gallery, Florida International University, Miami.

Fuller Goldeen Gallery, San Francisco, *Casting: A Survey of Cast Metal Sculpture in the 80's*, July 8 - August 28. Catalogue.

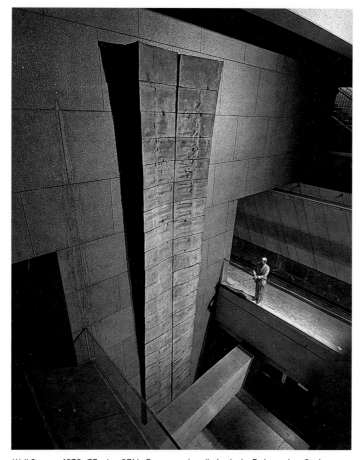

Wall Canyon, 1976-77, clay, 37' h. Permanent installation in the Embarcadero Station, Bay Area Rapid Transit District, San Francisco.

Kaiser Center, Oakland, California, *Brook House Sculpture Invitational at Kaiser Center,* August 2, 1982-January 19, 1983. Catalogue.

Maryland Institute College of Art, Baltimore, *Clay Bodies — Autio, De Staebler, Frey,* January 29-March 7. Catalogue.

Oakland Museum, California, *100 Years of California Sculpture,* August 7-October 17. Catalogue.

Okun-Thomas Gallery, St. Louis, *Figuration and Configuration,* March 13-April 17.

Palo Alto Cultural Center, California, *Palo Alto Sculpture Invitational,* June 27-October 27.

Antonio Prieto Memorial Gallery, Mills College, Oakland, California, *Imbued Clay Figures,* July 26-September 30.

Quay Gallery, San Francisco, *Figurative Clay Sculpture: Northern California,* April 6-April 30. Catalogue.

Richmond Art Gallery, California, *Four Bay Area Sculptors,* July 18-August 2.

North Terminal Connector Gallery, San Francisco International Airport, *Artists' Furniture,* June 21-September 17. Catalogue.

San Jose Museum of Art, California, *Pacific Currents/Ceramics 1982,* March 25-April 25. Catalogue.

Transamerica Pyramid, San Francisco, *Survey of Bay Area Figurative Sculpture,* July 8-August 16.

Women's Interart Center Gallery, New York, *Architectural Ceramics: A Documentation,* June 13-June 26.

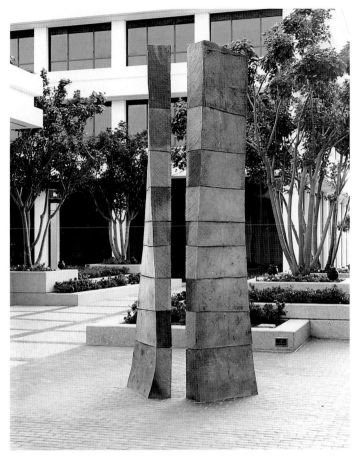

Canyon, 1981, clay, 14' h. Permanent installation at the Pacific Mutual Plaza,
Newport Beach, California.

1981 American Craft Museum, New York, *The Clay Figure*, February 6-May 31.
Catalogue.

California College of Arts and Crafts, Oakland, *Alumni Exhibition.*

Fuller Goldeen Gallery, San Francisco, *Polychrome*, December 2, 1981-
January 2, 1982.

Honolulu Academy of Arts, *Matter, Memory, Meaning*, March 14-April 12.
Catalogue. Traveled to Brunnier Gallery, Iowa State University, Ames; Kala-
mazoo Institute of Arts, Michigan; Institute of Contemporary Art, Richmond,
Virginia; Baxter Art Gallery, California Institute of Technology, Pasadena;
Midland Center for the Arts, Michigan; Beaumont Art Museum, Texas.

1980 California State University, Turlock, *Form and Figure: Bay Area Ceramic
Sculpture*, March 8-March 26.

San Francisco Museum of Modern Art, *20 American Artists*, July 24-
September 7. Catalogue.

San Mateo County Arts Council, Belmont, California, *Sculpture in Public
Places*, September 27-November 21.

1979 Everson Museum of Art, Syracuse, New York, *A Century of Ceramics in the
United States: 1878-1978*, May 5-September 23. Catalogue. Traveled to
Renwick Gallery, Washington, D.C.; Cooper-Hewitt Museum, New York.

Grossmont College Gallery, El Cajon, California, *Viewpoint: Ceramics 1979*,
April 24-May 22. Catalogue.

Humboldt State University, Arcata, California, *Clay Art: Paul Soldner, Stephen
De Staebler, Richard Shaw.*

Richard L. Nelson Gallery, University of California, Davis, *Large Scale Ceramic Sculpture*, February 26-March 30. Catalogue.

Oakland Museum, California, *Bay Area Artists*, September 25-October 6.

Pennsylvania Academy of the Fine Arts, Philadelphia, *Seven on the Figure*, September 9-December 16. Catalogue.

Security Pacific Bank, Los Angeles, *West Coast Clay Spectrum*, June 25-September 2. Catalogue.

Lubin House Gallery, Syracuse University, New York, *New Works in Clay I and II by Contemporary Painters and Sculptors*, April 26-June 26. Catalogue.

University Art Galleries, University of California, Santa Barbara, *Contemporary Ceramics*, April 4-May 6.

Walnut Creek Civic Arts Gallery, California, *Human Form*, February 1-March 24. Catalogue.

1978 Everson Museum of Art, Syracuse, New York, *Nine West Coast Clay Sculptors: 1978*, September 29-December 3. Catalogue. Traveled to Arts and Crafts Center of Pittsburg, Pennsylvania; Akron Art Institute, Ohio.

Joe and Emily Lowe Art Gallery, Syracuse University, New York, *New Works in Clay II*, December 10, 1978-January 17, 1979. Catalogue.

Newport Harbor Art Museum, Newport Beach, California, *The Figure: More or Less*, January 21-March 21.

Santa Rosa Junior College Art Gallery, California, *The Chair Show.*

1977 William Hayes Ackland Memorial Art Center, Chapel Hill, North Carolina, *Contemporary Ceramic Sculpture*, February 6-March 6. Catalogue.

College of Notre Dame Art Gallery, Belmont, California, *Selections from the Collection of George and Eva Neubert of Contemporary California Sculpture.*

Indianapolis Museum of Art, Indiana, *Perceptions of the Spirit in 20th Century Art*, September 20-November 27. Catalogue. Traveled to University Art Museum, Berkeley, California; Marion Koogler McNay Art Institute, San Antonio, Texas; Columbus Gallery of Fine Arts, Ohio.

Oakland Museum, California, *Bay Area Artists*, June 11-June 19.

Palo Alto Cultural Center, California, *Cross-Currents: Fiber to Sculpture*, January 18-February 27.

Santa Rosa Junior College Art Gallery, California, *Contemporary Figurative Sculpture*, November 6-December 14.

1976 California State University, Sacramento, *Invited Clay Works.*

Museum of Contemporary Art, Chicago, *American Crafts '76: An Aesthetic View*, June 26-September 5. Catalogue.

University Art Galleries, University of California, Santa Barbara, *Clay: The Medium and the Method*, April 7-May 9. Catalogue.

James Willis Gallery, San Francisco, *Retrospective of Sculpture in the Bay Area.*

1975 Carborundum Museum, Niagara Falls, New York, *Masterworks Exhibition.*

Helen Euphrat Gallery, De Anza College, Cupertino, California, *A Survey of Sculptural Directions in the Bay Area*, October. Catalogue.

Oakland Museum, California, *Bay Area Artists*, August 22-August 28.

Quay Gallery, San Francisco, *Garden Ceramics*, April-May.

The University of Colorado Art Galleries, Boulder, *The University of Colorado Ceramics Invitational*, June 13-August 15. Catalogue.

1974 Oakland Museum, California, *1974 California Ceramics and Glass*,
 March 2 - April 28. Catalogue.

 Oakland Museum, California, *Public Sculpture/Urban Environment*,
 September 29 - December 29. Catalogue.

1973 John Michael Kohler Arts Center, Sheboygan, Wisconsin, *The Plastic Earth*,
 June 22 - August 21.

1971 University of Nevada, Las Vegas, *Clay*, September 20 - October 8.

1969 Nordness Gallery, New York, *Objects: USA*. Catalogue. Traveled to National
 Collection of Fine Arts, Smithsonian Institution, Washington, D.C.; School
 of Fine and Applied Arts, Boston University; Memorial Art Gallery, Univer-
 sity of Rochester, New York; Cranbrook Academy of Art, Bloomfield Hills,
 Michigan; Indianapolis Museum of Art; Cincinnati Art Museum; St. Paul
 Art Center, Minnesota; Museum of Art, The University of Iowa, Iowa City;
 Arkansas Art Center, Little Rock; Utah Museum of Fine Arts, Salt Lake City;
 Seattle Art Museum; Portland Art Museum, Oregon; Los Angeles Municipal
 Art Gallery; Oakland Museum, California; Phoenix Art Museum; Sheldon
 Memorial Art Gallery, University of Nebraska, Lincoln; Milwaukee Art Center;
 Chattanooga Art Association; Fort Worth Art Center Museum, Texas; Museum
 of Art, Carnegie Institute, Pittsburg; Columbia Museum of Art, South Carolina;
 The High Museum of Art, Atlanta; Philadelphia Civic Center.

1968 Holy Spirit Chapel, University of California, Berkeley, permanent installation.
 Catalogue.

1965 American Express Pavilion, World's Fair, Flushing, New York, *Art '65 Lesser
 Known and Unknown Painters, Young American Sculpture — East to West*.
 Catalogue.

 Museum of Contemporary Crafts, New York, *Cookies and Breads: The Baker's
 Art*, November 20, 1965 - January 9, 1966.

1964 *International Exhibition of Ceramic Art*, Japan.

 Fulton Street Mall, Civic Center, San Francisco, *San Francisco Arts Commission
 Art Festival*, September 23 - September 27.

 Stanford Museum, Stanford University, Palo Alto, California, *Current Painting
 and Sculpture of the Bay Area*, October 8 - November 29. Catalogue.

1963 Musee d'Art Modern de la Ville de Paris, France, *Onze Sculpteurs Americains
 de l'Université de Californie, Berkeley*, September 28 - November 3. Catalogue.
 Traveled to University Art Museum, Berkeley.

 Oakland Museum, California, *Contemporary California Sculpture*,
 August 5 - September 15.

 Nicholas Wilder Gallery, Los Angeles.

1962 Berkeley Art Center, California, *Open House*.

 Museum of Contemporary Crafts, New York, *American Craftsmen's Council
 Exhibition*.

 San Francisco Art Institute, *Six Artists in Clay*.

1961 Museum of Contemporary Crafts, New York, *Contemporary Craftsmen
 of the Far West*, September 22 - November 5. Catalogue.

 Yale University, New Haven, Connecticut, *Art in Higher Education in the U.S.*

De Staebler and Jerome Johnson pouring bronze in their Albany, California, studio in the early 1960s.

BIBLIOGRAPHY

Compiled by Karene Gould

BOOKS

Adams, Doug, and Diane Apostolos-Cappadona, eds. *Art as Religious Studies.* New York: Crossroad, 1987, pp. 198-200.

Albright, Thomas. *Art in the San Francisco Bay Area, 1945-1980: An Illustrated History.* Berkeley and Los Angeles: University of California Press, 1985, pp. 138-140, 143, 162, 271-272, ill.

Anderson, Wayne. *American Sculpture in Process, 1930-1970.* Boston: New York Graphic Society, 1975, pp. 166-167, 177, ill.

Apostolos-Cappadona, Diane, ed. *Art, Creativity, and the Sacred: An Anthology in Religion and Art.* New York: Crossroad, 1984, pp. 24-33.

Ashton, Dore. *American Art Since 1945.* London: Thames and Hudson, Ltd., 1982, pp. 171-172, ill.

————. *Modern American Sculpture.* New York: Harry N. Abrams, Inc., 1967, pp. 41-42, ill.

Clark, Garth. *American Ceramics — 1876 to the Present.* New York: Abbeville Press, 1986.

————. *Ceramic Art: Comment and Review 1882-1977.* New York: E. P. Dutton, 1978, p. 178.

Clark, Garth, and Margie Hughto. *A Century of Ceramics in United States 1878-1978.* New York: E. P. Dutton in association with the Everson Museum of Art, 1979, pp. 136, 164, 167, 199, 216, 217, 282, 299, ill.

Dillenberger, John. *A Theology of Artistic Sensibilities.* New York: Crossroad, 1986, pp. 174-176.

Domergue, Denise. *Artists Design Furniture.* New York: Harry N. Abrams, Inc., 1984, pp. 67-69, ill.

Donhauser, Paul S. *History of American Ceramics: The Studio Potter.* Dubuque, Iowa: Kendall/Hunt Publishing Company, 1978, p. 167, ill.

Feinbaum, Robert, ed. *Art in the Community.* Oakland, Calif.: Center for the Visual Arts, 1977, pp. 33-34.

Foy, George, and Sidney Lawrence. *Music in Stone: Great Sculpture Gardens of the World.* New York: Scala Books, 1984, distributed by Harper & Row, pp. 110, 112-113, ill.

Hall, Julie. *Tradition and Change: The New American Craftsman.* New York: E. P. Dutton, 1977, pp. 165, 167, ill.

Harold, Margaret. *Award-Winning Art.* Fort Lauderdale, Fla.: Allied Publications, Inc., 1965, p. s36, ill.

Orr-Cahall, Christina, ed. *The Art of California — Selected Works from the Collection of the Oakland Museum.* San Francisco: Oakland Museum Art Department and Chronicle Books, 1984, p. 169, ill.

Speight, Charlotte F. *Hands in Clay.* Sherman Oaks, Calif.: Alfred Publishing Company, Inc., 1979, pp. 160, 163, 166, 167, 184, ill.

————. *Images in Clay Sculpture.* New York: Harper & Row, 1983, pp. 3, 14, 18, 40, 55, 89, 118-120, 145-146, 207, ill.

CATALOGUES

American Craft Museum. *The Clay Figure*. New York, 1981.

Amerson, L. Price, Jr. *Large Scale Ceramic Sculpture*. Davis, Calif.: Richard L. Nelson Gallery, University of California, 1979.

Andersen, Wayne V., and Brian O'Doherty. *Art '65: Lesser Known and Unknown Painters, Young American Sculpture — East to West*. Flushing, N.Y.: American Express Pavilion, World's Fair, 1965.

Bates, Mary, and Susan Moulton. *Works in Bronze — A Modern Survey*. Rohnert Park, Calif.: Sonoma State University, 1984.

Blesdoe, Jane K. *Figurative Sculpture: Ten Artists/Two Decades.* Long Beach: California State University, 1984.

Bolomey, Roger. *Forgotten Dimension . . . A Survey of Small Sculpture in California Now.* Fresno, Calif.: Fresno Art Center, 1982.

Campbell, David R. *Contemporary Craftsmen of the Far West*. New York: Museum of Contemporary Crafts, 1961.

Carpenter, Ken. *New Works in Clay I and II by Contemporary Painters and Sculptors*. New York: Lubin House Gallery, Syracuse University, 1979.

Chipp, Herschel B. *Onze Sculpteurs Americains de l'Universite de Californie, Berkeley.* Paris: Musee d'Art Moderne de la Ville de Paris, 1963.

Clark, Garth. *Viewpoints: Ceramics 1979*. El Cajon, Calif.: Grossmont College Art Gallery, 1979.

———. *New Works in Clay II.* Syracuse: Joe and Emily Lowe Art Gallery, Syracuse University, 1979.

Dillenberger, Jane and John. *Perceptions of the Spirit in 20th Century Art.* Indianapolis: Indianapolis Museum of Art, 1977.

Douglas, Diane M., and Gregory Knight. *Material and Metaphor: Contemporary American Ceramic Sculpture.* Chicago: Chicago Public Library Cultural Center, 1986.

Elsen, Albert. *Casting: A Survey of Cast Metal Sculpture in the '80s*. San Francisco: Fuller Goldeen Gallery, 1982.

Everson Museum of Art. *A Century of Ceramics in the United States: 1878-1978.* Syracuse, 1979.

Fairbanks, Johnathan L., and Kenworth W. Moffett. *Directions in Contemporary American Ceramics*. Boston: Museum of Fine Arts, 1984.

Foley, Suzanne, and Sherri Warner. *Pacific Currents/Ceramics 1982.* San Jose, Calif.: San Jose Museum of Art, 1982.

Gannett, George D., and Eudorah M. Moore. *Artist's Furniture*. San Francisco: North Terminal Connector Gallery, San Francisco International Airport, 1982.

Goodyear, Frank H., Jr. *Seven on the Figure*. Philadelphia: Pennsylvania Academy of the Fine Arts, 1979.

Helen Euphrat Gallery, De Anza College. *A Survey of Sculptural Directions in the Bay Area*. Cupertino, Calif., 1975.

Hobbs, Louise. *Contemporary Ceramic Sculpture*. Chapel Hill, N.C.: William Hayes Ackland Memorial Art Gallery, 1977.

Hopkins, Henry T. *Sculpture and Works in Relief*. San Francisco: John Berggruen Gallery, 1987.

———. *20 American Artists*. San Francisco: San Francisco Museum of Modern Art, 1980.

Hough, Katherine Plake, and Michael Zakian. *California Figurative Sculpture*. Palm Springs, Calif.: Palm Springs Desert Museum, 1987.

Houk, Pamela. *Clay.* Dayton, Ohio: Dayton Art Institute, 1985.

Hughto, Margie, and Judy S. Schwartz. *Nine West Coast Clay Sculptors.* Syracuse: Everson Museum of Art, 1978.

Jones, Harvey L. *Stephen De Staebler: Sculpture.* Oakland: Oakland Museum, 1974.

Jones, Mady. *Figurative Clay Sculpture: Northern California.* San Francisco: Quay Gallery, 1982.

Kaganoff, Sheldon. *Clay: The Medium and the Method.* Santa Barbara: University of California, 1976.

Kester, Bernard. *American Crafts '76.* Chicago: Museum of Contemporary Art, 1976.

Robert Kidd Gallery. *Major Concepts: Clay.* Birmingham, Mich., 1986.

Kuspit, Donald. *Artists Choose Artists III.* New York: CDS Gallery, 1984.

Lagoria, Georgianna M., and Fred Martin. *Northern California Art of the Sixties.* Santa Clara, Calif.: DeSaisset Museum, 1982.

Laky, Gyongy. *Matter, Memory, Meaning.* Honolulu: Honolulu Academy of Art, 1981.

Lang, Ron. *Clay Bodies — Autio, De Staebler, Frey.* Baltimore: Maryland Institute, 1982.

Levin, Elaine. *West Coast Clay Spectrum.* Los Angeles: Security Pacific Bank, 1979.

Lindberg, Ted. *Stephen De Staebler: An Exhibition of Recent Bronzes.* Vancouver: Emily Carr College of Art, 1983.

Lorio, James A., and Thomas Potter. *University of Colorado Ceramics Invitational.* Boulder: University of Colorado Art Galleries, 1975.

Lucie-Smith, Edward, and Paul J. Smith. *Craft Today: Poetry of the Physical.* New York: American Craft Museum, 1986.

Magloff, Joanna. *Current Painting and Sculpture of the Bay Area.* Palo Alto, Calif.: Stanford University, 1964.

Martin Z. Margulies Collection. *Contemporary Sculpture from the Martin Z. Margulies Collection.* Coconut Grove, Fla., 1986.

McClain, Malcolm A. *Artist's Forum: Selected Faculty Artists from the California State University.* Los Angeles: California State University, 1985.

Neubert, George W. *Brook House Sculpture Invitational at Kaiser Center.* Oakland: Kaiser Center, 1983.

————. *Contemporary Bronze: Six in the Figurative Tradition.* Lincoln, Neb.: Sheldon Memorial Art Gallery, University of Nebraska, 1986.

————. *1974 California Ceramics and Glass.* Oakland: Oakland Museum, 1974.

————. *Public Sculpture/Urban Environment.* Oakland: Oakland Museum, 1974.

Nordness, Lee. *Objects: USA.* New York: Nordness Gallery, 1969.

Perry, Barbara. *American Ceramics Now: Twenty-Seventh Ceramic National Exhibition.* Syracuse: Everson Museum of Art, 1987.

Philbrook Museum of Art. *The Eloquent Object.* Tulsa, Okla., 1987.

Rindfleisch, Jan. *Faces.* Cupertino, Calif.: De Anza College, 1984.

Roberts, Benita, and Jim Whiteaker. *Human Form.* Walnut Creek, Calif.: Walnut Creek Civic Arts Gallery, 1979.

Schmidt, James R. *Surface/Function/Shape: Selections from the Earl Millard Collection.* Edwardsville, Ill.: Southern Illinois University, 1985.

St. John, Terry. *100 Years of California Sculpture.* Oakland: Oakland Museum, 1982.

Troy, Jack. *American Clay Artists: Philadelphia '85.* Philadelphia: Port of History Museum, 1985.

Newman Center, University of California. *Holy Spirit Chapel.* Berkeley, 1968.

Van Den Abeele, Lieven. *The Monument in 20th-Century Sculpture.* Middelheim, Antwerp, Belgium: Open-air Museum for Sculpture, 1987.

Van Wagner, Judy Collischan. *The Doll Show: Artist's Dolls and Figurines.* Brookville, N.Y.: Hillwood Art Gallery, Long Island University, 1986.

ARTICLES

Abatt, Corinne. "Stretching Clay to New Dimensions." *Observer and Eccentric,* January 15, 1987.

Adams, Doug. "Modern Sculpture Emphasizes Human Body to Gain Transcendence." *Church Teachers*, November/December 1986, pp. 99-103, ill.

Albright, Thomas. "A New Step for De Staebler." *San Francisco Chronicle*, February 11, 1982, p. 68, ill.

_____. "Bruised, Battered, Bewildered." *Artnews*, September 1978, pp. 128-134.

_____. "Elusive Realism." *Artnews*, February 1980, pp. 181-183.

_____. "Forceful Imagery from Two Artists." *San Francisco Chronicle*, February 28, 1984, p. 42.

_____. "Intriguing Survey of Sculpture." *San Francisco Chronicle*, August 12, 1982.

_____. "Looking Back at a Unique Decade in Art." *San Francisco Chronicle*, November 1, 1982, *Datebook* section.

_____. "Masterful Monumental Slabs." *San Francisco Chronicle*, September 21, 1974, p. 31.

_____. "Material and Garish Problems on the Art Front." *San Francisco Chronicle,* November 4, 1982, p. 62.

_____. "Our Public Sculpture — A Disgrace?" *San Francisco Chronicle*, August 21, 1983, pp. 11-12.

_____. "Painterly Allegories and Ceramic Parables." *Artnews*, April 1977, pp. 88-89, ill.

_____. "Question of 'Contemporary' Art." *San Francisco Chronicle*, November 26, 1979, p. 46, ill.

_____. "Rogue's Gallery of Decadent Chic, Death-Like Figures." *San Francisco Chronicle*, September 29, 1981, p. 41.

_____. "Serene, Monumental Sculpture." *San Francisco Chronicle*, February 4, 1977, p. 42.

_____. "A Wide-Ranging Modern Art Exhibition." *San Francisco Chronicle*, August 3, 1980, *This World* section, pp. 35-36.

"All for Art's Sake." *San Francisco Chronicle*, May 27, 1965, p. 22.

Allman, Paul. "Art Who?" *New Vistas*, October 19, 1974, p. 14.

_____. "Man's Visions in Richmond." *Weekend Vistas*, May 19, 1978.

"American Craft Museum Presents 'The Clay Figure.'" *Sunstorm*, March 1981.

"Art in the Local Galleries." *San Francisco Sunday Examiner and Chronicle*, September 15, 1974, *This World* section, p. 38, ill.

Artner, Alan G. "Ceramics Display Fails to Lift Itself Higher." *Chicago Tribune,* February 14, 1986, sec. 7, pp. 52-53.

Ashton, Dore. "Objects Worked by the Imagination for Their Innerness: The Sculpture of Stephen De Staebler." *Arts Magazine*, November 1984, pp. 140-144, ill.

_____. "Perceiving the Clay Figure." *American Craft*, April/May 1981, pp. 24-31, ill.

Baker, Kenneth. "New York City Gets a Glimpse of Bay Area Art." *San Francisco Chronicle*, October 31, 1985, p. 65, ill.

Baker, Martha. "Laumeier: Thousands of Pounds of Art." *St. Louis Business Journal,* September 9, 1985, p. 1B+.

Barnard, Rob. "Craft in a Muddle." *New Art Examiner,* February 1987, pp. 24-27.

"Bart Chiefs Guard Against Art Burn." *San Francisco Examiner,* November 26, 1975, p. 22, ill.

Beckleman, John. *NCECA Newsletter,* January 1979, pp. 1-2, ill.

Bloomfield, Arthur. "Art To Put On or Sit On If You're So Reclined." *San Francisco Examiner,* February 3, 1977, p. 22, ill.

_____. "20 Years of San Francisco Sculpture." *San Francisco Examiner,* February 5, 1976, p. 24.

Blum, Walter. "A Showcase for Contemporary Art." *San Francisco Sunday Examiner and Chronicle,* August 10, 1980, *California Living Magazine,* pp. 16-21, ill.

_____. "Perceptions of the Spirit." *San Francisco Sunday Examiner and Chronicle,* December 25, 1977, *California Living Magazine,* pp. 4-6, ill.

Boettger, Suzaan. "Stephen De Staebler, John Berggruen Gallery." *Artforum,* March 1983, p. 80.

Brenson, Michael. "Also of Interest This Week." *New York Times,* June 15, 1984, p. C23.

Burkhart, Dorothy. "Outward Appearances: Palo Alto Puts its Art Where Public's Eye Is." *San Jose Mercury News,* June 17, 1982, p. 1D+.

_____. "The '60s Art Experience." *Tab San Jose Mercury News,* October 17, 1982.

Burstein, Joanne. "Eight Young Artists." *Artweek,* February 2, 1985.

_____. "Stephen De Staebler." *American Ceramics,* 1984, pp. 41-49, ill.

Caen, Herb. "The Rambling Wreck." *San Francisco Chronicle,* January 20, 1978, p. 35.

Chipp, Herschel B. "The 1963 Paris Biennale." *Artforum,* August 1963, pp. 7-10, ill.

Coffelt, Beth. "Public Art, the Agony and the Aesthetics (Part One)." *San Francisco Sunday Examiner and Chronicle,* August 1, 1982, *California Living Magazine,* pp. 12-15, ill.

_____. "Public Art, the Agony and the Aesthetics (Part Two)." *San Francisco Sunday Examiner and Chronicle,* August 8, 1982, *California Living Magazine,* pp. 10-15.

Colby, Joy Hakanson. "Two Looks at Clay's New Respectability." *Detroit News,* June 11, 1987, p. 7.

"Collectors' Forum Hosts a Glamorous Gathering of Artists, Collectors and Curators." *Sausalito Revue,* July 1980, p. 18.

"Colorado Invitational." *Ceramics Monthly,* November 1975, pp. 45-57, ill.

"Contemporary Ceramic Sculpture." *Ceramics Monthly,* October 1977, pp. 36-37.

Coplans, John. "Sculpture in California." *Artforum,* August 1963, pp. 3-6.

Craib, Ralph. "Bart Art." *San Francisco Chronicle,* November 26, 1975, p. 5, ill.

"Crocker Acquisition." *Sacramento Bee,* August 3, 1975, *Scene* section, p. 3, ill.

Croft, Karen. "Ceramics Matures as an Art Form." *Palo Alto Weekly,* May 14, 1986, p. 36.

Cross, Miriam Dungan. "A Captivating Memorial." *Oakland Tribune,* January 4, 1970, pp. 30-31, ill.

Curtis, Cathy. "A Survey and a Retrospective." *Berkeley Independent and Gazette,* August 3, 1980, p. 24.

_____. "Clay Figures, Rare Horses Are On View." *Peninsula Times Tribune* [Calif.], February 26, 1981, p. C7, ill.

Dawson, Fielding. "The Sculpture of Stephen De Staebler." *Rolling Stock* #9, 1985.

Degener, Patricia. "A Legendary Ceramist's Work Shown at Okun-Thomas Gallery." *St. Louis Post-Dispatch*, October 26, 1980, p. 5B.

———. "100 Years of Clay." *St. Louis Post-Dispatch*, March 17, 1980.

———. "Stephen De Staebler's Bronze Sculptures Transcend the Topical." *St. Louis Post-Dispatch*, September 30, 1984, ill.

Delehanty, Hugh J. "Feat of Clay." *Focus*, April 1982, pp. 23–27.

Demoro, Harre W. "Bart Says Rope Art Must Go." *San Francisco Chronicle*, March 18, 1987.

De Staebler, Stephen. "Keynote Address." *NCECA Journal*, 1984, pp. 9–13, ill.

Duffy, Robert W. "Sculptor Picked for Work Here." *St. Louis Post-Dispatch*, April 1, 1984, p. 10D.

Dunham, Judith L. "Figural Abstractions and Equine Miniatures." *Artweek*, February 21, 1981, pp. 5–6, ill.

———. "Functional Forms, Sculptural Concerns." *Artweek*, June 3, 1978, p. 1, ill.

———. "Human Vestiges in Landscape Forms." *Artweek*, December 15, 1979, p. 5, ill.

———. "Sculptures Of and About the Earth." *Artweek*, October 26, 1974, p. 5, ill.

———. "Stephen De Staebler: Time and the Figure." *Artweek*, March 12, 1977, p. 1+, ill.

Edwards, Sharon. "A Conversation with Stephen De Staebler." *Ceramics Monthly*, April 1981, pp. 60–62, ill.

Ewing, Robert. "The Artistic Age." *Orange Coast*, November 1982, pp. 26–33.

Figueiredo, Noel, et al. (Campus reaction to sculpture "Left-Sided Angel"). *Iowa State Daily* [Ames], September 3–October 16, 1986.

Fowler, Carol. "Engagement with the Human Figure." *Contra Costa Times* [Calif.], February 2, 1979.

Frankenstein, Alfred. "A Gallery Full of Sculpture." *San Francisco Chronicle*, January 29, 1976, p. 36.

———. "Burkeian Vastness, Infinity … And the Suddenness of Revelation." *San Francisco Chronicle*, January 1, 1978, *This World* section, p. 34.

———. "Ceramic Show the Latest Moves of the Establishment." *San Francisco Chronicle*, December 16, 1962, *This World* section, p. 24.

———. "Painted Steel and Other Works." *San Francisco Chronicle*, May 11, 1978, p. 59.

Franz, Gina. "Perceptions of the Spirit in Art." *Columbus Tonight* [Ohio], June 9, 1978.

Frederick, Warren. "Stephen De Staebler." *New Art Examiner*, February 1987, p. 56.

Garmel, Marion Simon. "Religious Art Returns as 'Spiritual Perception.'" *Indianapolis*, September 21, 1977, p. 58.

Glueck, Grace. "'The Clay Figure' at the Craft Museum." *New York Times*, February 20, 1981, p. C21.

Gottlieb, Shirley. "The Human Body: Back But Never Gone." *Weekend-Press Telegram*, 1984, pp. 6–7.

Gronborg, Erik. "Clay, Exhibition of Ceramics." *The Nevadan*, October 3, 1971, pp. 27–28.

Hall, Jacqueline. "Exhibition Displays Spirit in 20th Century American Art." *Columbus Dispatch*, May 10, 1978, p. C11.

Hall, Julie. "In Public Spaces." *Ceramics Monthly*, May 1978, pp. 32–34, ill.

Hancock, Lorie. "Real Art is Really Good." *The Union* [California State University at Long Beach], March 22, 1984, p. 6.

"Hansen Fuller Goldeen Exhibiting Stephen De Staebler." *Sausalito Revue*, March 1982.

Harper, Paula. "De Staebler's Fragmented Figures Convey Physical, Psychic Strength." *Miami News*, May 17, 1985, p. 3C, ill.

Hartranft-Temple, Ann. "Slab Form Dominates Lowe's Clay II Exhibit." *Syracuse Post-Standard*, December 31, 1978.

Herr, Marcianne. "West Coast Ceramics." *Dialogue* [Akron Art Institute], March/April 1979, pp. 7-9, ill.

Hoone, Kay O. "Show of Ceramics by Painters and Sculptors Opens at Lowe Gallery." *Syracuse Post-Standard*, 1979.

Hurd, Ruth H. "New Art in Public Buildings Work Installed." *State of the Arts,* November/December 1983, pp. 4-5, ill.

Jepson, Barbara. "New Quarters for the Best in American Crafts." *Wall Street Journal,* November 6, 1986, p. 30.

Jones, Harvey L. "De Staebler Show Opens Sept. 10." *Art* [Oakland Museum Association], September/October 1974, pp. 4-5.

Kamin, Ira. "The Art of Hanging Out." *San Francisco Sunday Examiner and Chronicle,* October 22, 1978, *California Living Magazine*, pp. 47-53.

Kessel, John Keith. "Five Figurative Sculptors." *Artweek*, December 3, 1977, p. 15.

Klemperer, Louise. "Accidents Will Happen, Soldner Hopes." *Willamette Week* [Portland, Ore.], July 8, 1980.

_____. "Building With De Staebler." *Willamette Week* [Portland, Ore.], June 24, 1980, ill.

Kohen, Helen L. "Great Effort Goes Into 'Effortless' Art." *Miami Herald*, May 19, 1985, p. 5L, ill.

Knoerle, Jane. "This House is for 'Adults Only.' " *Country Almanac*, February 1, 1984, pp. 28-30, ill.

Lansdell, Sarah. " 'The Spirit' Broadly Defined at Indianapolis." *Courier-Journal,* November 20, 1977.

"Laumeier to Display De Staebler Bronzes." *St. Louis Globe-Democrat,* September 21, 1984.

Leddy, Thomas. *Zenger's*, March 9, 1977, pp. 17-18, ill.

Ledger, Marshal. "The Body is Back!" *Philadelphia Inquirer*, September 30, 1979, *Today Magazine*, pp. 22-25, ill.

Levin, Elaine. "Stephen De Staebler." *Ceramics Monthly*, April 1, 1981, pp. 54-59, ill.

Marechal-Workman, Andree. "Stephen De Staebler at Hansen Fuller." *Images and Issues*, Summer 1982, p. 81, ill.

_____. *Westart*, March 12, 1982, p. 3.

McColm, Del. "Art Isn't About Winning." *Davis Enterprise Weekend* [Calif.], June 12, 1986.

_____. "Testaments to the Human Spirit." *Davis Enterprise* [Calif.], March 15, 1984, ill.

_____. "Voluptuous Shoes." *Davis Enterprise* [Calif.], February 12, 1976, ill.

Meisel, Alan. "Heavy Clay by Stephen De Staebler." *Craft Horizons*, February 1975, pp. 30-31, ill.

Montini, E. J. "Ghostly Fragments Mark Sculptor's Work." *Arizona Republic,* January 3, 1984, ill.

Morch, Al. "A Major Show of California Sculpture Rates Oscar." *San Francisco Examiner*, August 16, 1982.

_____. "Different Artistic Generations, Same Artistic Ballpark." *San Francisco Examiner*, February 3, 1986, p. E2, ill.

_____. "Sculpture Around the Bay." *San Francisco Examiner*, August 4, 1982, pp. E6-E7.

_____. "We're Still in the Bronze Age." *San Francisco Examiner*, August 2, 1982, p. E6.

Morse, Marcia. "The Primal Past of a Spiritual Archaeologist." *Sunday Star-Bulletin and Advertiser*, July 8, 1984, ill.

Muchnic, Suzanne. "The Way We Are, Figuratively." *Los Angeles Times*, March 3, 1987, *Part VI*, p. 1+.

"New Sculpture Honors Ostwald." *Berkeley Gazette*, February 20, 1976, ill.

Nordstrom, Sherry Chayat. "Lowe's 'Works in Clay II' An Exciting Exhibit." *Syracuse Post-Standard*, January 1, 1979, p. 17.

O'Connor, Tom. "A Muse to Use: Making Furniture As Art." *Focus*, October 1982, p. 36+.

Parker, Bill. "Berkeley Sculptors are Favored for Bart." *Berkeley Independent Gazette*, 1975.

Perreault, John. "Fear of Clay." *Artforum*, April 1982.

Pincus, Robert L. "Santa Monica." *Los Angeles Times*, September 17, 1982.

Polley, Elizabeth. "Focus on Art." *Focus*, November 1974, p. 16.

"A Portfolio of California Sculptors." *Artforum*, August 1963, pp. 16-58, ill.

"Public Art Sculpture." *San Francisco Chronicle*, December 21, 1975, *This World* section, p. 31, ill.

Ratcliff, Carter. "Report from San Francisco." *Art in America*, May/June 1977, pp. 55-62, ill.

Raynor, Vivien. "Art: Seven Sculptors at Penn Plaza." *New York Times*, June 15, 1984, p. C23.

Regan, Kate. "The SFMMA [San Francisco Museum of Modern Art] at 50." *San Francisco Chronicle*, December 16, 1984, p. 1+.

Richardson, Brenda. "California Ceramics." *Art in America*, May/June 1969, pp. 104-105, ill.

Ruff, Dale. "Along The Clay Spectrum." *Artweek*, August 25, 1979.

Schlesinger, Ellen. "A Dark Vision." *Artweek*, March 31, 1984, p. 4, ill.

"Sculpture Exhibition Opens Sunday." *Peninsula Times Tribune* [Calif.], June 24, 1982, p. C1+.

"Sculpture Gala Centered at Oakland." *Davis Enterprise Weekend* [Calif.], August 12, 1982, p. 9.

Shapiro, Howard-Yana and James Yood. "Ceramic Art: Wading into the Mainstream?" *New Art Examiner*, April 1986, p. 22-24.

Shere, Charles. "An Exhibit Looks at the '60s." *Oakland Tribune*, November 7, 1982, p. H25.

_____. "Impressive Showing of Bay Sculpture." *Oakland Tribune*, February 22, 1976, p. 18E, ill.

_____. "Museum Displays That Sculpture." *Oakland Tribune*, October 13, 1974, p. 25.

_____. "Vitality Spills Out from Canvases of Young Bay Artists." *Oakland Tribune*, February 6, 1986, p. C1+, ill.

Slivka, Rose. "The American Craftsman." *Craft Horizons*, March/April, 1964, p. 10+, ill.

Sommers, Jason. "De Staebler Comes Home for Laumeier Exhibition." *Webster-Kirkwood Times*, September 28–October 4, 1984, ill.

Steele, Sabrina. "Art Exhibit Explores Human Form." *Daily Forty-Niner*, April 12, 1984, pp. 5–6.

Steilen, Debra. "Campus Statue Draws Mixed Reaction." *Ames Daily Tribune* [Iowa], August 20, 1986, p. B4, ill.

"Stephen De Staebler." *Artnews*, December 1985, p. 132, ill.

"Stephen De Staebler." *Ceramics Monthly*, September 1978, pp. 28–29, ill.

Stiles, Knute. "Stephen De Staebler at Willis." *Art in America*, November/December 1978, pp. 158–159, ill.

Stofflet-Santiago, Mary. "Manifestations of the Spirit." *Artweek*, January 14, 1978, p. 1+.

Tarshis, Jerome. "Stephen De Staebler at Hanson Fuller Goldeen." *Art in America,* October 1981, p. 153.

Taylor, Dan. "Bronze Look." *Press Democrat*, October 19, 1984, p. 1D.

Taylor, Sue. "Ceramics Break Out of Mold." *Chicago Sun-Times*, March 13, 1986, p. 78.

Temko, Allan. "Casting: Bronzes in Disguise." *San Francisco Examiner*, July 22, 1982.

———. "The Airport's Latest Flights of Fancy." *San Francisco Chronicle*, August 5, 1982, *Datebook* section.

"The Gallery Scene." *Bay Area Lifestyle*, March 1976, ill.

Tolf, Robert. "Saluting Contemporary Statuary …" *Fort Lauderdale News/Sun-Sentinel*, March 5, 1981.

Tuchman, Phyllis. "The Sunshine Boys." *Connoisseur*, February 1987, pp. 63–69, ill.

"Up Against the Wall." *Oakland Tribune*, December 7, 1975, ill.

Weiner, Bernard. "Critic's Choice." *San Francisco Chronicle*, February 13, 1982, p. 34.

Weisberg, Ruth. "Stephen De Staebler at Tortue." *Images and Issues*, January/February, 1983, p. 63, ill.

———. "Ten Sculptors Working with the Figure." *Artweek*, April 14, 1984, p. 1, ill.

"West Coast Clay Spectrum." *Ceramics Monthly*, January 1980, pp. 40–42, ill.

White, Cheryl. "The Clay Slab." *Artweek*, June 7, 1986, p. 5.

White, Ron. "'Spirit' Survives at McNay." *San Antonio Express*, March 13, 1978.

Winter, David. "Reliving 'Northern California Art of The Sixties.'" *Peninsula Times Tribune* [Calif.], November 2, 1982, p. C3.

Wisenberg, Sandi. "Dashing Dahlia Morgan." *Miami Herald*, May 10, 1985, p. 1E+, ill.

Wolff, Theodore F. "Art Galleries Present Summer Fare for All Tastes." *Christian Science Monitor*, July 7, 1986, p. 27+.

FOUNDRY CREDITS

The bronze sculptures illustrated in this catalogue were cast at the following foundries:

Artist's Studio, Albany, California
Man with Melting Mouth (unique cast)

Artworks, Berkeley, California
Archangel (unique cast)
Bisected Woman Standing (unique cast)
Blue Torso Column (artist's proof)
Clubwinged Angel (unique cast)
Head with Bated Breath (artist's proof)
Head with Mask (base only, artist's proof)
Left-Sided Angel (unique cast)
Left-Sided Figure Pointing (unique cast)
Leg VIII (artist's proof)
Man on One Leg (unique cast)
Man with Flame (unique cast)
One-Legged Woman Standing (unique cast)
Pregnant Woman II (unique cast)
Pregnant Woman IV (unique cast)
Right-Sided Angel (artist's proof)
Seated Man with One Leg (unique cast)
Seated Woman Standing (unique cast)
Sitting Woman (unique cast)
Standing Figure with Blue Shoulder (2/3)
Standing Man with Stone (unique cast)
Wedged-Winged Man with Hollow Heart (unique cast)
Winged Woman (unique cast)

Bronze Aglow, Inc., Walla Walla, Washington
Left-Sided Figure Standing (cast 1/4)
Seated Man Bisected (artist's proof)
Seated Man with Winged Head (artist's proof)
Seated Woman Bisected (artist's proof)
Seated Woman with Oval Head (artist's proof)
Wedged Man Standing II (artist's proof)
Wedged Man Standing III (artist's proof)

Nordhammer, Oakland, California
Face with Blue Eye (unique cast)
Female Torso (unique cast)
Man with Lip-Eye (unique cast)
Man with Tar Heart (artist's proof)
Pregnant Woman (artist's proof)

PHOTOGRAPHY CREDITS

Scott McCue was photographic consultant for this publication and took all of the photographs, with the following exceptions:

Peter W. Brown: pages 20, 127; M. Lee Fatherree: pages 11, 12, 18; plates 10, 13, 15, 16, 18, 19, 20, 23, 25, 29, 38, 40, 44, 47, 51, 52, 61, 62, 63, 64, 65; Susan Felter: page 27; Pete Krumhardt: plate 9; Jim McHugh: page 6; Douglas Parker: page 129; Pollitzer, Strong and Meyer: plates 39, 41; Karl H. Riek: pages 125, 126, 128.

143